GHOSTS OF CHESTERTOWN AND KENT COUNTY

D.S. DANIELS

Haunted America

Published by Haunted America
A Division of The History Press
Charleston, SC 29403
www.historypress.net

Copyright © 2015 by D.S. Daniels
All rights reserved

Front cover: The Geddes Piper House, circa 1783, served as the headquarters of the Historical Society of Kent County folowing its purchase in 1956 and subsequent restoration.

Unless otherwise noted, all images appear courtesy of
the Historical Society of Kent County.

First published 2015

Manufactured in the United States

ISBN 978.1.62619.969.9

Library of Congress Control Number: 2015942277

To Karen Emerson
Friend, colleague and comrade-in-arms
Thank you for everything

CONTENTS

ACKNOWLEDGEMENTS

My thanks to Karen Emerson and Joan Andersen, the most competent, hard-working and fun-to-be-with staff a director could desire. I appreciate all the help you gave to me in the preparation of this book as well. My appreciation also to Robert L. Bryan, Steve Frohock, Roger Brown, Ann Charles, officers; and all the members of the board of directors of the Historical Society of Kent County for their continual support.

Unless noted, all images in this book are from the marvelous collection in the Historical Society of Kent County's library, which is open to the public on a regular basis.

I thank all the people who helped me gather tales for this book, including Tracy Stone, John Carroll, Teddi Zia, Jeanette Sherbondy, Tony Hurley, Mary Woodland Gould Tan, Margaret Gould Cummings, Clarence Hawkins, Milford Murray, Cynthia Sanders, Joan Horsey, Davy McCall, Michael Bourne, Mark Newsome, Jack Bigelow, Larry Slagle, Cheryl Harris and all the owners and staff of homes and properties included in this book. My special thanks to Jim Maitland and Stephen Edwards of LightSeekers Paranormal Resolutions; Rodney Whitaker of the Maryland Society of Ghost Hunters; to Bryan Talbott and You Know You're From Kent County When...Facebook Friends; and to Kevin Hemstock for being such a good resource for everything historic.

My thanks to all those who helped me put together the ghost walks, including Rachel Field for helping me collect stories; Deborah Lane for helping me organize the first walk; Anna Striegl, Bill Seidleck and all

the other talented ghost walk guides; members of Phi Alpha Theta of Washington College for being great ticket takers; and wonderful interns Emily Broderick, Kasey Jones and Erin Benz.

Thank you to all the people of Chestertown and Kent County whom I had the pleasure of knowing and working with through the years. And thanks to the many whom, when I went from talking about local history to asking about ghosts, treated my inquiries with good sport and great interest.

And my greatest appreciation always to my family: my late husband, Bill Daniels, and my wonderful daughter and son-in-law, Anne and Joe McLaughlin, for their love, support and faith in me and all my endeavors.

INTRODUCTION

In writing this book, there were times that I wondered if I was writing a book about history or a book about ghosts. The simple answer to that question is that it is about both.

Even if I had wanted to write a book just about ghosts, I would find it difficult to talk about anything regarding Kent County without talking about its history. This lovely little county on the Chesapeake is unique in that an extraordinary portion of its landscape and built environment continues to reflect the centuries of history played out on its fields and shores and in its towns and villages.

Tucked on to a peninsula bordered by the Chesapeake, the Chester and the Sassafras Rivers, Kent County is the tiniest of Maryland counties both in geography and population, with only 413 square miles, 136 of that in water, and around twenty thousand residents, only seven thousand more than in the 1790 census. Yet it has ten Century Farms, three National Register Historic Districts and over seven hundred sites on the Maryland Inventory of Historic Properties. Chestertown, the county seat, with only around 5,270 residents, boasts more eighteenth-century homes still in use than any Maryland community other than Annapolis. Its riverfront promenade of grand houses, some built by planter merchants whose enterprise and industry led Chestertown to become a center of colonial economic and cultural activity, has cast much the same reflection in the Chester River for over three centuries.

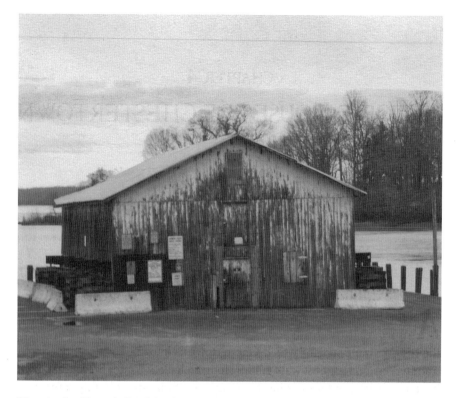

The wharf at Turner's Creek has been used since the eighteenth century, and the Granary has stood since the nineteenth century.

Rock Hall, Galena and Millington began as villages that served as stopping points for travelers since English-speaking people first arrived. The first settlers of what is now Betterton were supposedly helped by Native Americans, and Captain John Smith embarked on its shores.

Colonial estate houses, some still lived in by the same families who settled there in the seventeenth and eighteenth centuries, can be found throughout the county. Kent County has the highest percentage of acreage devoted to agriculture of any Maryland county, and soil tilled centuries ago still remains as farmland. The still active wharf at the public park of Turner's Creek was a distribution point for grain to supply the Revolution.

The windswept marshes of Eastern Neck Wildlife Preserve look much as they might have when English settlers first took up land grants there in the 1650s. And at the churchyard of old St. Paul's, perhaps the oldest remaining religious structure on the Eastern Shore, souls lie buried who

died long before America became a country. Washington College is the tenth-oldest college in America and the first to be founded after we became a country. Caulk's Field is still a cornfield, as it was two hundred years ago, and is among the most pristine battlefields in the United States. One of only two African American GAR Halls left in the country is a center of community activity today.

But history isn't just about historic sites and structures. History tells us a story about the intertwining of people, land and events that shape us. And what makes a story better than a ghost?

Entertainment isn't the only reason I share the ghost stories of Kent County along with its history, although I confess when I wrote a script for a ghost walk for the Historical Society of Kent County, it was. But in the search for ghostly tales related to historic properties, I began to accept that people were sharing experiences with me that were every bit as real as the fact that George Washington did, indeed, sleep in Kent County.

Certainly some of the tales contained here are simply the stuff of legend. Some are anecdotes of magical practices brought from across the seas, and

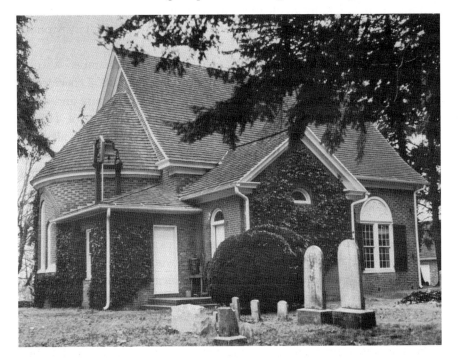

St. Paul's Church, circa 1692, is among the oldest religious structures remaining on the Eastern Shore.

some are just unusual incidents. But for most of the stories shared in this volume, there seems to be no explanation other than to say that some echos of the past can exist side by side with the present.

George Washington once said, "Death is the great abyss from which no one can return." Could he have been wrong? This I can say with surety: if Kent County has more than its share of history, it also has more than its share of ghosts.

Contained herein, roughly divided by time period, is the story of Kent County, along with the encounters of its living residents with those who are not.

THE GEDDES-PIPER HOUSE

The Geddes-Piper House, longtime home of the Historical Society of Kent County, is tucked away on Church Alley in Chestertown. It's a stone's throw from the main thoroughfare of High Street, yet visitors often have difficulty finding it or fail to recall on what street they'd been after they leave. From High Street down Court Street—more familiar as Lawyer's Row to the locals, where tiny offices have housed attorneys for over a century—past the back entrance to the courthouse, turn down Church Alley, and you'll find the Geddes-Piper House on the right where it has sat since it was built in the 1780s.

The lot itself had been purchased by James Moore in 1730 and from his daughters, by William Geddes, "Collector of His Majesty's Customs for the District of Chester," in 1771. The property was sold to James Piper and his wife, Tabitha, in 1784. There remains some question of whether Geddes or Piper built the house, but it was likely James Piper.

A Philadelphia-style town house, the first of its kind in Kent County, the Geddes-Piper House was built at a time when the industrious James Piper—a merchant and watch maker who also ran a packet boat on the Chester River—might have thought Chestertown could become a second Philadelphia. A bustling shipping port, the first area in Maryland to transition from tobacco to wheat production, and the shortest route between Virginia and points north, Kent County had realized tremendous economic activity during the 1700s.

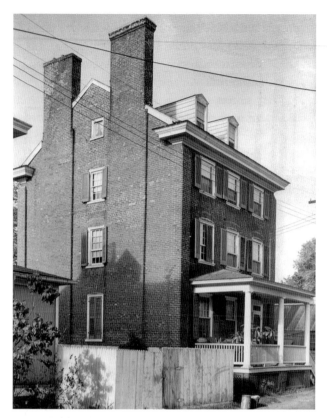

Left: The Geddes-Piper House when it was still a residence.

Below: Present-day Emmanuel Church was originally Chester Parish. Its eighteenth-century rector William Smith was instrumental in forming the Episcopal Church in America, thereby breaking away from the English Anglican Church.

Culturally, with its theater, horse racing, a gentlemen's club, parties and balls, colonial Chestertown was to the Eastern Shore what Annapolis was to the rest of Maryland.

"Tonight there is another Concert and Ball I shall just go and hear the Music. Of the Races I say nothing. They are a burlesque upon that diversion," wrote Henrietta Tilghman, sister of General Washington's aide-de-camp, Tench Tilghman, of Chestertown in 1783.

Washington College had been founded that same year by William Smith, rector of Chester Parish, now historic Emmanuel Church in the heart of Chestertown. (Smith had also been instrumental in establishing the Episcopal church in America, as he and his fellow Anglican priests had been bound to swear allegiance to the king.) Smith persuaded George Washington to sit on the college's Board of Governors and Visitors; one of Washington's eight trips to Chestertown was to attend a board of governors meeting in 1784.

But the glory days were coming to a close. As land opened up in the west in Pennsylvania and Ohio and the port of Baltimore rose to preeminence, the Eastern Shore would become isolated, and Chestertown, although continually prosperous, would never again see the activity that it had enjoyed during the colonial era.

Mr. Piper soon followed fortune across the bay to Baltimore, and the house passed through several owners until it was purchased by George Burgen Westcott in the 1830s. Westcott, an enterprising man from New Jersey, became one of the most successful businessmen in mid-nineteenth-century Kent County. The house would remain in the Westcott family until the early 1900s, when Polly Wickes Westcott moved to a smaller home after the death of her servant Charles, without whom she said she couldn't handle "the old brick house."

The house served briefly as a Moose Lodge and then a girls' school. Church Alley became a small African American neighborhood

George Burgin Westcott purchased the Geddes-Piper House in the 1830s. The Westcott family resided there until the early twentieth century.

for several decades; during that time, the Geddes-Piper House was an apartment building. The historical society purchased the building in 1958, and its refurbishment ushered in the significant restoration that would lead Chestertown to become a National Landmark Historic District.

Inside, the Geddes-Piper House is beautifully furnished with period pieces and artifacts in various decorated rooms, including the house's original cellar kitchen. The society's office is on the second floor, and the research library is on the third (at the time of this writing, plans are underway to move these to the Bordley History Center in the middle of town).

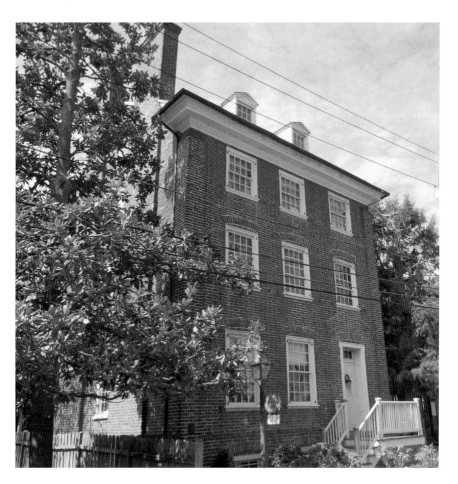

The Geddes-Piper House served as the headquarters of the Historical Society of Kent County following its purchase in 1956 and subsequent restoration.

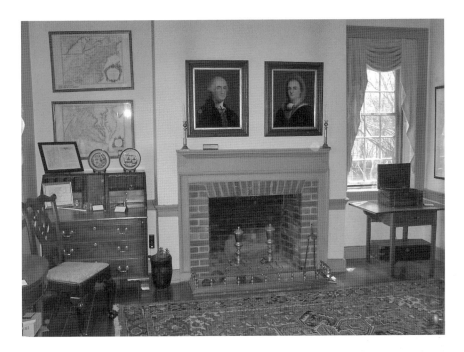

The front parlor of the Geddes-Piper House.

When I became executive director of the society, I didn't think about ghosts. I thought about history. History to me is all about stories—true ones, of course, but stories nonetheless. Many of the tales from Kent County history far surpass any work of fiction in excitement, adventure and human drama. So, instead of concentrating on materials culture and decorative arts, traditionally the emphasis of many house museums, we began to use each decorated room as a backdrop to tell the story of a particular time in local history, appealing to a much broader audience than Hepplewhites and Chinese Export.

In the process, we moved furniture around and changed things that had apparently been in the same position for many years. We had more visitors, more events and more researchers coming to the library.

As our activity increased, I started to get stories back from our visitors. Some, of course, were about various aspects of local history and genealogy, but many were very specific to the Geddes-Piper House itself.

It seemed that some people were seeing things that I certainly didn't.

The first report came from a guest who arrived very late to one of our new events: First Friday History Happy Hour. As executive director, I

was also the dishwasher and was cleaning up when two people who had misunderstood the hours of the event stepped into the darkened house. I invited them to wander through the house while I finished up. It was a winter's night, and only a few electric candles glowing softly in the windows lit their way.

The couple came back to the working kitchen on the first floor, where I had just put away the last of the wine glasses.

"Do you know you have a ghost?" the lady asked.

"No," I replied, not certain what to say.

"I know it sounds strange," she said, "but I see things. There's a little girl looking out the window on the landing of the stairs leading up to the library." She described a child with blond ringlets and an old-fashioned dress peering out at the house's backyard, darkened by the winter's night.

I had long understood that some people seemed to be "sensitive" to things that I couldn't see or hear. I'd also always been open to all possibilities; after all, life itself can be so strange, filled with the unexpected, so who was I to judge someone else's experience? I thought little of it at the time.

But as it turned out, I would come to be familiar with the phrase "I see things," most always prefaced with "I know this sounds strange."

More than one visitor saw the little girl, always on the second floor or above, often looking out one of the windows. Soon it appeared that the little girl had company.

People started reporting the presence of a diminutive woman, also on the upper floors. We began to refer to her as "Aunt Polly," for Polly Westcott, a very petite lady whom many of the old guard in town had identified with the house. On more than one occasion, we caught the scent of lavender on the first floor, so possibly Aunt Polly did wander down to check things out. We were a bit disrespectful by referring to it as "the smelly ghost," even though it was a very pleasant scent.

Things got even stranger when a visitor came in with an old Polaroid camera. "Can I take some pictures?" he asked. I welcomed him to do so. We were not about roped off-areas and stanchions—one time I'd even talked a weary board member into using the front bedroom to take a nap.

The man came back to proudly show me his photographs. The most striking was of the stairs leading up to the third floor; in the middle was the ghostly image of a woman's face and shoulders, floating above the steps.

"I guess this sounds strange," the photographer said, "but I see things. That's why I like to take photos in old houses. You can see a lot of things like this in old houses, but they only show up on the film."

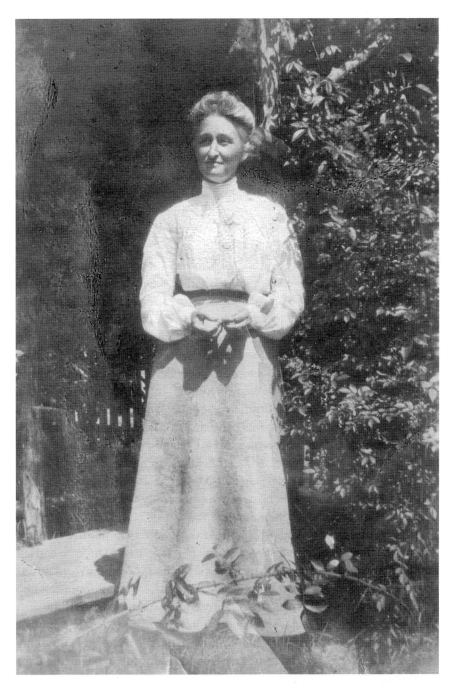

Polly Wickes Westcott was the last of the Westcott family to live in the Geddes-Piper House.

Sometime later, one of the volunteers came down from the third floor and mentioned not knowing that our librarian (herself a very tiny lady) was still there. "Hadn't she taken a tour out?" the volunteer asked. I replied that yes, she had.

"But I just saw her. I *spoke* to her," said the volunteer. She turned around and went back upstairs to check.

"Well, I guess I've finally seen Aunt Polly," she could only conclude when she came down from the empty library.

I recalled a comment made by the former cleaning lady of the Geddes-Piper House, who finished her work early in the morning before we opened. The woman told me, "I always say to Polly, 'Come on, let's go clean.'"

Although the little girl and Aunt Polly seemed to be the most outgoing of the entities or whatever it was that visitors were sensing, there appeared to be others.

I conducted an oral history with a lady who as a child lived in the house with her family when it was an apartment building. Her bedroom was what had become the first-floor kitchen. By that time, I had no shame about the matter and boldly asked if she had ever seen a ghost.

Yes, she had—a tall white man with dark hair standing in the corner. She was lying in her bed when she saw him. When she sat up, he disappeared.

I couldn't help but wonder, could that have been old G.B. Westcott? Up until then, that was the only "sighting" mentioned of a presence on the lower floors.

While no part of the house was "creepy"—indeed, it has a very pleasant feeling to it—some people felt uncomfortable in the original cellar kitchen. But then, cellars, like attics, can do that to people.

The cellar kitchen was used until the 1830s rear addition put the kitchen upstairs. With its ancient brick work and giant hearth, it's the most original-looking part of the house. But with few exceptions, the fantastic collection of domestic artifacts on display in the cellar were from the late nineteenth and early twentieth centuries, which was a bit frustrating to me because we weren't truly depicting the activity that would have taken place there.

One Friday evening, I was working after hours when a visitor knocked on the door. She apologized for her late arrival but asked if she could look around. A contract medical professional at the local hospital, she said she had to leave the next day and really wanted to see the house. Although not thrilled to have a guest when I wanted to go home for the evening, I invited her in while I finished up my work.

She looked around the lower floors and then came back up to my office.

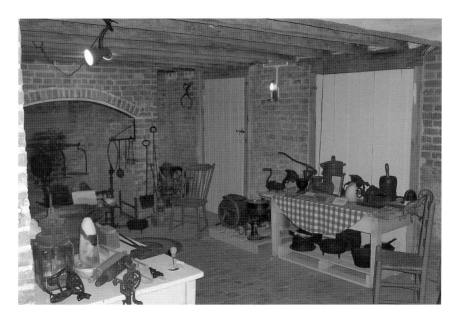

The original cellar kitchen of the Geddes-Piper House.

"I know this sounds strange," she began, "but I see things."

I told her that it was not uncommon for people to say that and that I had concluded some people were "sensitive" to something that I could not see or hear in the house, but whatever it was, it was not a disturbing presence.

"There's a lot of activity in the kitchen in the cellar," she said.

"Oh?" No one had yet said that about the kitchen. I was curious if she would say she saw the "lady of the house" in the cellar. Some visitors had the idea that the family would have used the old kitchen and gathered around the hearth while the mother cooked. But the early kitchen in the house would have been the domain of slaves and servants.

"I see several black women down there," continued the visitor. "They're trying to do their work but seem frustrated because they don't have the proper tools." She looked at me quizzically.

"That's right!" I exclaimed, feeling a bit vindicated over my concern with the anachronistic artifacts. "Most of those things don't belong in that time period!"

She wandered around the second floor (with so few staff and volunteer docents only on weekends, we commonly let guests explore on their own in the museum part of the house) and then asked to go upstairs, so I

accompanied her and even took her up to the attic, used for storage. By then, her visit was providing a much more interesting diversion than anything I'd planned for the evening.

"There's a little girl up here," she said—again, words I'd heard before. But she had a look on her face different then that of other visitors, even the ones who also could "see things."

"I know I'm sounding even weirder," she said, "but the little girl is ready to pass on to the other side. Her family is waiting for her outside the window."

I had always thought the idea of a child ghost or whatever the presence was so very poignant. True, before antibiotics, vaccinations and the other miracles of modern science, any house of a certain age would have seen its share of death and, if a family lived there, very likely the death of a child or children.

Not to say that I yet believed in ghosts. I'm not certain what I believed, other than that just the idea of a child's spirit looking out the windows of an old house for decades, even centuries, had always moved me.

"I think I'm supposed to help her pass on," the woman said, still looking puzzled. "I've never done anything like this before."

With that comment, she really had me intrigued. This had become *way* more interesting than anything I'd planned for the evening.

"What do you want to do?" I asked, uncertain what else to say. I didn't fully believe that what she sensed was real, but I found myself caught up in the idea, like a teenager attracted to the notion of playing with a Ouija board.

"Well," she replied hesitantly, "I guess you should leave me alone, and I'll try and help her."

For a moment, I was disappointed. I thought I'd get to see a psychic guide, or whatever she was, in action. However, there was nothing of real value in the attic, I had no feeling that she was untrustworthy and I certainly wasn't much help as a ghost counselor, so I went to leave.

"Wait!" she stopped me. "She wants you to stay." The woman looked at me and then to the empty space beside me. "She *likes* you. I think *you* should talk to her."

To this day, I wonder what the expression on my face looked like. I'd undertaken a number of unusual projects in my life, but no one had ever asked me to help a ghost pass on to the "other side."

"She seems very comfortable with you," the visitor assured me.

I felt a bit impolite, as I certainly couldn't see the supposed child ghost who had taken a shine to me, and indeed, I had never given real thought to

whether I believed her to even exist. I also felt more than a bit awkward; just how close was I coming to acting really foolish?

"Her parents are waiting outside," the visitor said with some urgency.

For whatever reason, I decided I was game and sat down on a chair by the window. I looked at the still empty space beside me, thought what it would be like if there was indeed the spirit of a child lingering too long in an old house, what it would be like if her parents were truly waiting outside to be joined again by their little girl and how tragic it would be to be parted not only in life but also in death.

I cleared my throat, put aside my misgivings, let my imagination guide me and, to the best of my recollection, these are the words I spoke:

"Go on now, your parents are waiting, just outside the window. You don't want to stay here, wandering around this old house. This isn't any place for a little girl to be, not for all these years. Go on and be with them, be with your family. Go now, they're waiting," my voice had dropped to a whisper. "Go and join them."

"She just put her arms around you!" the visitor exclaimed. "She's gone!"

I had felt nothing (except perhaps a bit foolish) and seen nothing, but if there was any chance I had indeed helped the spirit of a child move on, I suppose I was satisfied.

"See," said the visitor, "you *are* sensitive to the spirit world."

"No," I replied, "I just have a vivid imagination."

Before the woman left, she told me she had been leaving work at the hospital and felt a need to find the local historical society. "I saw you were closed," she said, "but something told me I had to come in. Things like that happen to me, but never anything like this.

"You know," she added, "the spirits here feel very protected by you. I still think you see more than you realize."

I did not admit to her, but the only thing I had begun to see were dollar signs. I had been to Gettysburg, gone on one of its ghost walks and stayed at one of its haunted inns. Could we market the ghosts of Chestertown and Kent County? I concluded we should have a ghost walk, but first, I needed more ghost stories, and I set out to collect them. In the process, I came to understand that, indeed, there is far more to history than meets the eye.

CHAPTER 2
KENT COUNTY BEGINNINGS

ON THE SHORES OF THE CHESTER

Many years ago on a moonlit night when crabs were beginning to shed, a man living on Front Street in Chestertown finished "bedding down" the fertilizer at the Hubbard Plant along the river, turning it over so it wouldn't start to smolder. He then set out in his skiff to crab, working his way upriver with his dipnet, staying close to the shoreline on the town side. When he reached the marshes north of where Heron Point sits now, he looked across the river to Duck Neck near the old campground. There on the beach he saw a fire, with figures moving in the moonlight beside it.

There was no sound, no laughing or talking as could usually be heard by a bonfire at night, just the silent figures, the smell of smoke and a shape that he later swore looked like a wigwam. He gathered his crabs and rowed toward the fire, his back to the farther shore. When he got to the beach, there was no fire, no wigwam, no people and no footprints, only the lingering smell of smoke.

"I saw history tonight," the man told his family when he got home. "I swear I saw history."

"Have you been drinking?" his wife demanded to know.

The story was shared with me by Tony Hurley, a well-known and highly respected native of Chestertown whose roots go back to the Nanticoke tribe of the Eastern Shore. The man was his neighbor's father. "He never drank," the neighbor told Tony. "I know that for a fact."

Duck Neck, Tony told me, has long been known as a good site for people looking for Native American artifacts. Stone tools, pottery shards and projectile points have littered the soil for at least centuries.

The tale is different than most I have heard, as it would appear to be a case that some describe as a time slip, in which people seem to observe and sometimes even claim to participate in events that took place in another time period. Perhaps the most famous such reported incident is that of Anne Moberly and Eleanor Jourdain, principal and vice-principal, respectively, of St. Hugh's College, Oxford, who were visiting Versailles in 1901 and claim to have found themselves temporarily in the time of Marie Antoinette.

Whatever the reason for this story of a Native American campfire burning on the banks of the Chester, I begin with this tale as it is the only one I came across that reflects on the original people of the region.

People arrived on the Eastern Shore at least twelve thousand years ago, after melting glaciers flooded what is now the Susquehanna River Valley to form the Chesapeake Bay. They used the vast waterways as part of an extensive network of trade and began farming around 800 BC, eventually planting corn, beans, squash and tobacco, long before Europeans arrived to almost completely displace them.

In 1608, Captain John Smith explored the Sassafras, stopping at a Tockwogh village, possibly near Turner's Creek.

"Heaven and Earth never agreed better to frame a place for man's habitation," he wrote of the Eastern Shore, enticing other Englishmen to follow him.

OLD BROADNOX

The first English settlement in Maryland was established in 1631 by William Claibourne on Kent Island, a site perfectly situated for trade with the Native Americans. In 1634, Cecilius Calvert, the Second Lord Baltimore, established a colony on land granted to his family with a first settlement at St. Mary's City. Kent Island was within the Calvert proprietorship and became Kent County in 1642. The Calverts and Claibourne clashed for decades over its ownership, but Lord Baltimore's claim held.

Land grants were offered to settlers in exchange for a fee; those who brought more than five men with them were granted one thousand acres. The population of Kent Island expanded, and people moved across the Kent Narrows and began to settle present-day Kent County in the 1650s, claiming land along water routes first and holding their first court in this new settlement in the home of Joseph Wickes on Eastern Neck Island.

Life here could be very brutal. With its warm, humid climate and threat of malaria, English settlers who survived a year in the Chesapeake were considered "seasoned." The primary labor force through much of the seventeenth century were indentured servants bound to their landed masters for a period of years in exchange for transportation to America. Although many lived through their terms of indenture to become freemen and often landowners themselves, some of them even elected to public office, during their servitude they were almost completely at the mercy of their masters.

Kent County court records from the 1600s show Thomas Ward and his wife accused of beating a servant to death, but both were acquitted as it was determined the maid was in such a weakened state to begin with that the beating was not the cause of her demise. In nearby Talbot County, a servant ran into the river to escape a harsh beating and drowned; the cause of his death was determined to be suicide. There were rare instances of masters being hanged for the death of a servant in seventeenth-century Maryland, but more commonly, if actually found guilty of murdering an underling, a landowner might suffer branding on the hand and a fine of tobacco, the currency of the day, paid to the court. On the other hand, a common punishment for even trivial offenses by a servant was to be lashed until blood was drawn.

A particularly unsavory character from this period was Thomas Broadnox, whose land patent of 1659 is now part of Chesapeake Farms near Rock Hall. Court records show a series of suits brought against him including theft, rape and drunkenness. Records of the hearings regarding the last charge against him, his wife and their drinking buddy John Salter read like a tawdry burlesque of the landed "gentry." Apparently the three, along with the absent Mrs. Salter, were what would centuries later be referred to as "swingers." The articulate servants called as witnesses appear by their recorded statements to have taken great delight in describing in excruciating detail a tale of fornication ("his britches were down to his knees and her skirts were up to her breasts"), assault and attempted rape (by Mr. B against Mrs. B) acted out in front of them by their "betters."

But there was no humor in the testimony of the Broadnox servants in a later case, in which both Mr. and Mrs. Broadnox were accused of causing the death of a servant through repeated beatings, refusing to allow the other servants to bring him food or water and forcing him to drink his own urine for six days. The Broadnoxes in turn charged one of the servant witnesses with "conspiracy." Broadnox died before any conviction could be made, and the court refused to prosecute his widow.

"Seventeenth century Maryland could accept extreme cruelty and violence in free white men and might even find such men useful," wrote C. Ashley Effelson in *Seven Hangmen of Colonial Maryland*. Such seemed to

be the case, as Thomas Broadnox is mentioned as a man of "considerable importance" in Earl Swepson's *Maryland's Colonial Eastern Shore*.

Yet over 350 years later, the cruelty of Broadnox is remembered locally. Natives of the Rock Hall area recall being told as children that he haunts Broadnox, the house that bears his name.

The legend of the haunting has two versions, both recalling his cruelty. In one, Broadnox himself is supposedly buried in the front of the house standing upright so that he could cast his evil gaze over his servants until kingdom come. In the other version, it is the abused servant (local legend refers to him as a slave) who was buried upright in the front yard as a punishment, forced to face the house and his cruel master through eternity. Children would ride their bikes out to Broadnox and jump up and down in the front yard, trying to make the earth shake from the fury of the ghost of old Broadnox.

Kent County has other wonderful old country homes from this earliest of time periods, also with rumors of ghosts. Mr. Swepson, in describing one of the Eastern Shore's historic estates, mentions, "Like most of these old houses…it has a haunted chamber." But unfortunately, I found no one to share details of hauntings of other seventeenth-century properties.

Mrs. Mildred Strong of the magnificent house Trumpington of Eastern Neck, built on the land her ancestor Thomas Smyth I purchased in 1687, was asked if she'd ever seen or heard anything unusual in her home.

"Some say they've seen this or that," replied the esteemed lady, "but I haven't. And if there are any ghosts, they're my family."

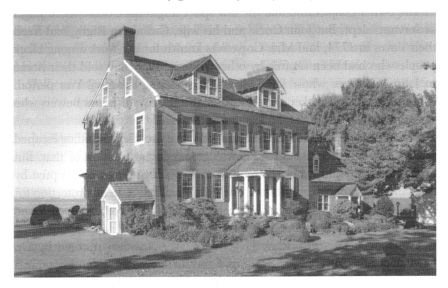

Trumpington on Eastern Neck sits on land granted to the Smyth family in the 1680s and remains in the family to the present day.

CHAPTER 3

COLONIAL CHESTERTOWN

Chesapeake settlement patterns were different than in the Pennsylvania and New England colonies. Plantations rather than towns were initially the focus of activity, but the Maryland General Assembly pushed for the formation of towns as centers of trade.

In 1680, the town of New Yarmouth was established on Eastern Neck Island along Grey's Inn Creek by James Ringgold and Samuel Tovey. The settlement was to be a county seat and a courthouse was built, but the enterprise lasted less than twenty years. As the new section of the county expanded, it seemed that the town was not conveniently situated for regional trade. After Tovey's death, Ringgold was accused by his former business partner's widow of essentially cheating her out of her inheritance from her late husband, but the court failed to support her.

In any case, New Yarmouth was abandoned, as was old St. Peter's Church on Eastern Neck Island, to be replaced by St. Paul's Parish, established farther inland in 1692. It is not even quite certain where New Yarmouth was, although residents have claimed for generations to occasionally glimpse its ghostly remains beneath the surface of Grey's Inn Creek, depending on the winds, the tide and the stillness of the marshy waters.

Although references are somewhat vague, another town seemed to have been started on Quaker Neck in 1697 and apparently a courthouse erected, but that, too, was abandoned.

In 1706, at about the same time the present-day boundaries of Kent County were established, a new town was founded along the Chester River

and designated as the county seat. Interestingly, much of the land purchased for the New Town, as Chestertown was called for much of the century, belonged to Thomas Joyce, the husband of Tovey's widow. It's amusing to wonder if perhaps Joyce, who had essentially been denied his wife's inheritance by Ringgold, didn't pull in all his chits, so to speak, to have the old county seat abandoned and relocated to his property. But that is to be considered "just reward," not fact.

Simon Wilmer, who owned the Stepney Estate, of which the manor house still exists slightly south of Chestertown, purchased most of the lots in town. It was through his efforts and his resurvey of the town that, by the 1730s, Chestertown had become a bustling center of activity. The transition of Kent County planters from tobacco to a more diversified, grain-based agriculture led to a boom in the region's economy. Tradesmen and craftsmen moved into town. One of the official ports of entry in the British colonies, Chestertown became a busy center of international trade. The harbor was filled with brigantines and schooners from many ports of call, and sleek, locally built craft set sail carrying wheat, pork and other products down to the Caribbean, up to New England and across the Atlantic.

THE KENT COUNTY COURTHOUSE

One of the first buildings erected in Chestertown was the Kent County Courthouse. Although it soon burned down and had to be rebuilt, and then a new one built again in 1860, it has essentially stood on the same site since 1707.

Little more than a decade ago, the courthouse attained worldwide notoriety for being haunted. A Washington College student intern at the historical society said she first learned of Chestertown by reading about its courthouse ghosts in an online news item from Spain.

It is widely known throughout the community that many who worked at the courthouse, particularly at night, grew accustomed to hearing doors opening and closing for no reason and footsteps on the stairs and in the hallways and seeing shadows moving and misty forms floating in the empty corridors. When a new security camera was installed in 2004, video footage showed what appeared to be a large orb of light floating above the main stairway. A *Washington Times* article of August 2004 described the security officer, with eyewitnesses present, going up the stairs while the video monitor

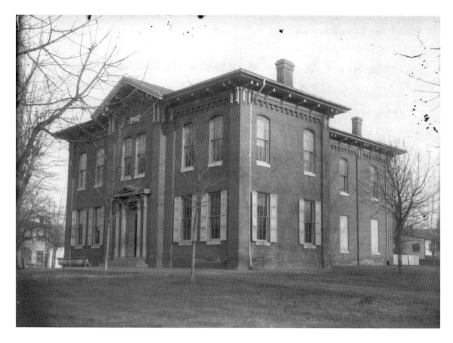

The Kent County Courthouse before its present restoration.

showed the orb moving ahead of him. The orb paused when he stopped and then started again when he proceeded, until it suddenly halted, and the officer moved through it.

"I felt a real chill, I will tell you that," the officer said, words seldom spoken in Kent County on an August day.

Yet, as a former courthouse employee who had personally experienced the unusual occurrences told me, "Not one of us watching that monitor was surprised by what we saw."

If a place needs a reason to be haunted, the courthouse would have several, but I'll begin with a particularly ghastly incident from the colonial period.

Justice in Maryland continued to be brutal through the 1700s. Enslaved Africans began to replace indentured servants as the primary workforce. Also bought and sold by local merchants were convict servants deported from England. All of these groups received little legal protection from the abuse they suffered under their masters. It was not uncommon for servants and slaves to be identified by scars and disfigurements from whippings, beatings, brandings, ear croppings and neck and leg irons, punishments meted out by

their masters outside the realm of the court but perfectly acceptable in the rigid, class-based planter system of colonial Maryland.

The courts could be every bit as brutal. Existing Maryland court records from the period between 1723 and 1775 show twenty-six people publicly branded for thievery, one in Kent County, and scores of convict laborers and slaves ordered to be shackled in irons on their necks and legs, including several in Kent County.

During that same time period in Maryland, hundreds were hanged, and approximately twenty people, mostly slaves, were hanged and gibbeted, their corpses hoisted in irons and chains and left to dangle in public until they rotted as a warning to others. Even more gruesome, about twenty slaves were quartered, their bodies cut into pieces and publicly displayed following execution. Although some of these particularly dreadful punishments took place on the Eastern Shore, none was in Kent County.

However, the courthouse in Chestertown was the place of the most hideous of public-sanctioned executions in Maryland history.

In April 1746, Hector Grant and James Horney, indentured servants, and Esther Anderson, listed as a convict servant, were sentenced to death for the murder of their master, Richard Waters. Grant and Horney were to be hanged, but Esther Anderson was to be burned to death.

Notice of the execution that appeared in the *Maryland Gazette* stated simply, "Esther Anderson is to be burned." The reason for this inhumane sentence is unclear, although it quite possibly had to do with English sensibilities about what constitutes a "ladylike" execution. Until the end of the eighteenth century, an Englishwoman who murdered her husband or master could be charged with "petty treason," as either man was considered her superior. If convicted, she could be sentenced to burn at the stake, while men who killed their masters were hanged. As hanged men could also be quartered and gibbeted, thus exposing their naked bodies to the public, being burned at the stake was apparently considered more "seemly" for a woman, according to some sources.

The sentences of Grant, Horney and Anderson were carried out in May, presumably on the lawn of the courthouse. In those days, executions were very public events, and people traveled from distances to view them, but they would never have seen anything like the burning of Esther Anderson.

There were incidents of "private" punishments by burning of slaves by white people, such as the killing of "Negro Anne," a thirteen-year-old child who was tied to a stake with straw piled by her feet and set fire to by Richard and Susanna Harris of Somerset County in 1688. The Harrises

were fined—not for having killed the little girl but because she had been someone else's slave. But, to the extent that Maryland records indicate, there had never been and would never be again a court-ordered execution by burning other than that of Esther Anderson.

People would have likely crowded to see Esther taken to the place of execution outside the courthouse and fastened to a stake. Wood would have been piled around her and then lit by the official hangman. If she was fortunate, she would have had a rope or chain around her neck, which the hangman could pull tightly before the flames engulfed her, essentially hanging her at the stake, or she could have succumbed by suffocation from the smoke before the fire got to her. In either case, she would have been spared the agony of slow death by burning, a process that could take up to an hour.

If such was not the case, if there was no rope to jerk and choke her to death and the smoke didn't asphyxiate her, the crowd would have gotten quite a show that day.

They would have witnessed the flames creeping up her lower extremities, incinerating her clothes, her flesh, finally reaching her torso and at last her head. They would have heard the screams of the tortured Esther Anderson, seen her skin blackened and peeling away, caught her final shriek and that last glimpse of her terrified face before the flames ate away at any evidence that she had once been a living human being.

That would have been the reality of that horrible event. But when one thinks of the strange happenings in the courthouse—the sounds heard in the darkened corridors, the shadows lurking in the empty chambers, the feeling of being watched—one might wonder, is Esther Andersen among those fleeting shadows haunting the courthouse? Did Esther's tortured soul rise with the smoke that billowed from her lifeless body, rise into the air above the courthouse lawn, above the gawking crowd, and embed itself for eternity into the scene that was the last she would bear witness to, with eyes filled with terror and agony? Is she the misty figure that has been seen floating through the halls of justice at night, searching perhaps for the men who condemned her not just to death but also to unimaginable horror?

Perhaps, but later centuries would also offer contenders for the spirits that seem to haunt the courthouse, as we shall see in time.

OUT OF THE ORDINARIES

Not all of colonial life was so dire, of course. A booming economy, excellent farmland and bustling towns offered a good life and plenty of work for many in Kent County. Local planter families whose genealogies were intertwined to a mind-boggling extent not only with one another but also with many of the key players elsewhere in colonial America brought both tremendous wealth and influence to the region.

An excellent education was available to the sons of the upper class at the Kent County Free School, where young gentlemen learned mercantile and navigation skills. Charles Peale, father of Charles Wilson Peale, the famed portrait painter of the Revolutionary period, became its headmaster. This post would eventually be taken by William Smith, who would use the school as the foundation for Washington College.

As was noted previously, balls, concerts and theatrical performances entertained the wealthy, as did constant visiting and parties in one another's homes. A gentlemen's club, styled after Annapolis's fashionable Tuesday Club, provided a popular diversion for men of position.

But for just about all white men with coins in their pockets and a taste for liquor, there was always a social outlet to be found in the colonial "ordinaries," as taverns were referred to in the day.

Great emphasis was placed in the colonies on the establishment of ordinaries and inns along well-traveled roads and near courthouses. It was deemed important not only for travelers to have somewhere to rest and refresh their horses but also for men of influence to have a public meeting place to gather and discuss issues of the day. Busy ferry crossings, such as Rock Hall on the bay, Georgetown on the Sassafras and Head of Chester (present-day Millington), were among those that had licensed tavern keepers.

Chestertown was no exception, and the town's taverns catered to local residents and to the many travelers who found Kent County to be the shortest route between Virginia and Philadelphia and points north. Many luminaries of the eighteenth century made the journey across the Bay from Annapolis to Rock Hall, through Kent County to Chestertown, on to Georgetown and northward from there. George Washington's diaries record eight trips through Kent County, and both Rock Hall and Chestertown can boast with surety that the Father of Our Country did, indeed, sleep there. (Worrell's Tavern of Chestertown, referred to specifically by Washington, was unfortunately torn down in the twentieth century, and all that remains

of the site where the future first president definitely stopped for a rest is a historic marker.)

It's important to note that colonial Kent County was not an out-of-the-way location. Central Pennsylvania was still the frontier, while Kent County was in the heart of colonial life. Even by the first census of 1790, Chestertown was the geographic center of the early American population. With its commercial and cultural activities and its location along a well-traveled route, Chestertown was a colonial destination. Travelers exclaimed on the beauty of the town, the handsome brick houses and commercial establishments, the number and variety of craftsmen and the quality of its taverns.

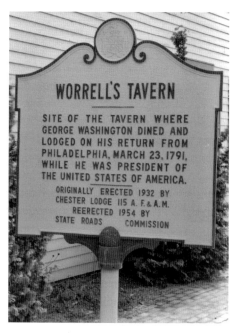

Historic marker indicating the site of Worrell's Tavern, mentioned in George Washington's diaries as a rest stop during one of his eight trips through Kent County.

A description of Walter Dougherty's tavern on High Street appeared in Dr. Alexander Hamilton's 1744 *Itinerarium*, a witty, sophisticated travelogue of the Annapolis physician's journey from the mid-Atlantic to Maine widely used in colonial studies today. Dr. Hamilton was impressed by his "comical chat" with Mr. Dougherty and described with delight a performing female baboon in the tavern's yard that "had more attendants and hangers-on at her levee than the best person (of quality as I may say) in town. She was very fond of the compliments and company of the men and boys, but expressed in her gestures an utter aversion at women and girls."

But not all conversation at Chestertown taverns was by any means frivolous. Among the planter merchants of Kent County were many influential players in the Revolutionary period. It is almost certain that one of the most important meetings in Kent County history took place at a tavern.

On May 13, 1774, six months after the Boston Tea Party, prominent Kent County men gathered to respond to the Tea Act. The act was not a new tax but favored the flagging East India Company in tea trade to the colonies

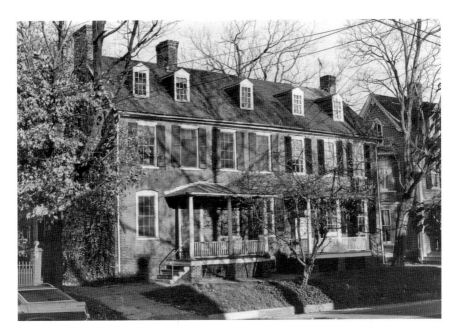

This charming residential home in Chestertown was the bustling Dougherty's Tavern during the colonial period.

while cutting out the American merchants. At a second meeting on May 18, the same group met again and approved the Chestertown Resolves, which essentially said they pledged allegiance to King George (remember, they were all still British citizens at this point), but they didn't want any of his tea, nor did they want to have anything to do with those who did.

The Resolves were followed by a postscript: "The above resolves were entered into upon a discovery of a late importation of dutiable tea (in the brigantine *Geddes* of this port) for some of the neighbouring counties. Further measures are in contemplation, in consequence of a late and very alarming act of parliament."

"The alarming Act of parliament" could have been the Boston Port Bill of March 1774 (news did not necessarily travel fast back then), which closed the Boston harbor in retribution for the December 1773 Boston Tea Party. The closing of the port of Boston would have had a significant impact on Chestertown merchants who traded with New England.

"Further measures are in contemplation" probably referred to the establishment of a committee of correspondence, with Thomas Smyth as chairman and Thomas Ringgold and James Nicholson among its members.

Their mission was to share information with similar committees throughout the colonies, and in June, they proposed to "offer a subscription for the poor inhabitants…[of Boston] who may be distressed by the stagnation of business." Chestertown became one of the first communities in the colonies to send supplies to the beleaguered city.

Samuel Adams replied to this gesture: "We cannot but applaud the spirit and determined virtue of the Town of Chester…[which] bodes well for the liberties of America."

The brigantine *Geddes* that carried the dread tea was considered to have been a locally built ship owned by William Geddes, custom inspector, merchant (he had previously been warned by the inspector general of customs to quit moonlighting but ignored the reprimand) and owner of the Geddes-Piper House lot.

Local tradition long held that Chestertown had its own "Tea Party" on May 23, when angry citizens marched down the street in broad daylight to board the *Geddes* and dump the tea in the river. However, no evidence exists that such an event took place. Also, James Nicholson, one of the signers of the Resolves and a committee member, owned the tea, so it is highly unlikely that "angry citizens" would have rallied against him.

Nonetheless, it is easy to imagine that members of the newly formed committee, proud but perhaps a bit nervous of their stance, fortified themselves with strong liquor; told Nicholson, "Come on, man, you've got to get rid of the tea"; walked down to the wharf (that would be the "in broad daylight" part of the legend); dumped the tea in the river (while Nicholson flinched but went along); and then all went back to the tavern to drink up again because they were about to become traitors to the British Crown.

What we *do* know that the leaders of Kent County did next was to step out of the taverns and into history. Thomas Smyth and Thomas Ringgold helped draw up the constitution for the new state of Maryland. Smyth, who served on the Maryland Council of Safety, financially supported the Revolution at the expense of his own economic stability. James Nicholson became one of the highest-ranking officers of the Continental navy.

Other Revolutionary notables from Kent County included Lambert Wickes of Eastern Neck, captain of the *Reprisal*, the first armed ship to carry the American flag in foreign waters. After dropping off Benjamin Franklin in France, Wickes captured a number of English "prizes" that helped the fledgling American navy purchase French vessels.

Alexander Murray was captain of the First Maryland Regiment and also became master of several private vessels that captured British ships.

Benjamin Chambers was lieutenant, and other Kent County men served in the Maryland Battalion that became famous as the Maryland 400, bravely holding the line (thereby bestowing Maryland's nickname, the "Old Line State") to allow Washington and his troops to retreat safely at the disastrous Battle of Long Island.

But the most memorable role played by a local man in the American Revolution was that of Tench Tilghman, Washington's aide-de-camp. After Cornwallis's surrender on October 19, 1781, Tench was chosen to ride with all speed from Yorktown to Philadelphia to announce to the Continental Congress the incredible news of final victory for the new country. It took him four days to make his historic ride. He traveled up through Alexandria, on to Annapolis, across the bay to Rock Hall, past Edesville and Old St. Paul into Chestertown, up to Georgetown to cross the Sassafras and on through Wilmington, arriving in Philadelphia at midnight on October 23. As it was told, he stopped at towns and farmhouses along the way when his mount tired, crying out, "Cornwallis is taken! A fresh horse for Congress!"

Soon after Tench delivered the news to Thomas McKean, president of the Continental Congress, Philadelphia watchmen echoed the proclamation throughout the city, "All is well and Cornwallis taken!" The people of the city awoke, and the bells of liberty tolled for the new nation.

The final stanza of Clinton Scollard's poem captures the historic ride:

> *In dreams, Tench Tilghman, still you ride,*
> *As in the days of old,*
> *And with your horse's swinging stride,*
> *Your patriot tale is told*
> *It rings by river, hill and plain,*
> *Your memory to crown,*
> *"Cornwallis' taken! Cornwallis' taken!*
> *The World Turned Upside Down!"*

Kent County legends offer some support for the poet's words, as people living out near Edesville and St. Paul's Church (where Tench Tilghman's father, James, is buried) and residents along High Street in Chestertown have for generations reported hearing ghostly hoofbeats at night, galloping across the countryside and through the end of town.

There were many others from Kent County who took part in the Revolution through military service, increased production for the war

effort, financial support and simply taking a stand as patriots to the cause of American independence.

The Delmarva Peninsula supplied as much as one-fifth of the wheat and flour and one-half of the corn received in Philadelphia in 1774. Donaldson Yeats and John Cadwalader of Kent County became quartermasters, obtaining grain and provisions for the American troops. Wheat shipments from the Chester River district for the Revolutionary cause equaled those of the entire western shore above Annapolis and two and one-half times more than the rest of the Eastern Shore.

Although no Revolutionary battle or even skirmish was fought on Kent County soil, the little county was truly part of the first great moment in the history of the United States of America.

Chestertown's taverns must have been humming for the duration of the war. And after Tench Tilghman's ride, citizens of the town celebrated widely, and gentlemen repaired to the taverns to drink a dozen toasts, first to George Washington and ending with a toast to the state of Maryland.

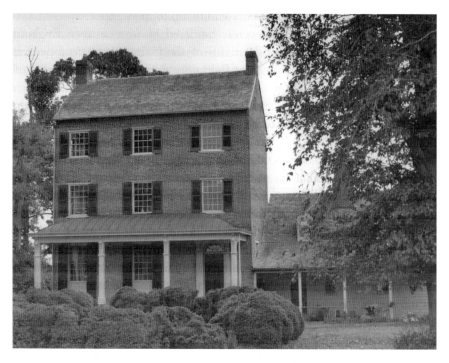

Knock's Folly, now open to the public, was the home of Donaldson Yeates, quartermaster during the Revolution, who shipped grain for the war cause from his wharf at Turner's Creek.

Even Chestertown businesspeople such as Rebecca Dunn, tavern owner, and Henry Phillips, a licensed liquor merchant and former slave who had managed to purchase himself from Thomas Smyth, would at least have benefited financially from the busy Revolutionary period. As history has shown, women and black people had a long while to wait after the Revolution to see any liberties actually bestowed on them.

At least two of the buildings that housed colonial taverns in Chestertown remain. According to local accounts, one still might experience a "night out of the ordinary" within their walls.

The White Swan Tavern, in the heart of Chestertown, began as the site of a tannery until the lot was sold to Joseph Nicholson in 1733. For more than 125 years it served as a tavern, apparently operating under the names of its various owners but always advertised as being conveniently situated directly across from the courthouse. In 1862, it was sold to the Eliasons. Newcomers from Delaware, the Eliasons became very influential in Kent County. The first T.W. Eliason and his son had living quarters in the old tavern while they transformed it into a mercantile establishment, which it remained until 1971. Purchased by the Havemyers, it was exquisitely restored as a tavern and inn, albeit one much more comfortable than it would have been in its earliest period.

Beautifully decorated rooms acknowledge the White Swan's various owners and the periods they represented. The historic atmosphere of the main tavern room, where afternoon tea is served, easily takes the imagination of the inn's patrons back centuries to the colonial era. Artifacts from the extensive archaeological investigation done before the restoration of the inn are on display, helping to elicit the out-of-time sensation that many guests have mentioned feeling during their stay.

The inn's permanent resident seems to prefer one period in particular, according to staff. The Victorian Lady, as she is called, has been witnessed by staff and guests watching passersby on High Street from the T.W. Eliason Victorian Suite's window. Some have described her as appearing in the dress of that period, while to others, she is a transparent ghostly image of a woman with little detail. To all who have noticed her, however, she is a gentle and always peaceful presence.

At least once, however, she has been known to play tricks. A housekeeper was vacuuming in the Victorian Suite one day when the cord didn't stretch as it usually did, and then suddenly the vacuum stopped. When the housekeeper turned to check the plug, she saw the cord not only unplugged but also floating in midair, as if being held up by an invisible hand.

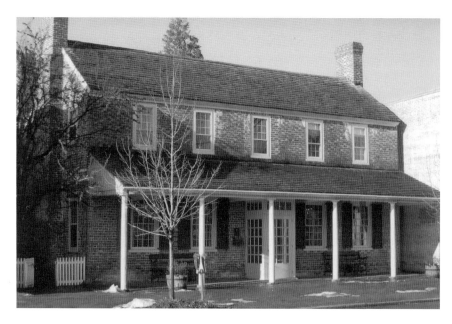

The White Swan Tavern in Chestertown operated as a tavern and inn during the eighteenth through mid-nineteenth centuries.

It is interesting to wonder, was this Victorian Lady the deceased first wife of Thomas Wilson Eliason? Her described dress seems to be of the period when the Eliason name would begin to appear in the records of so many of the transformational enterprises the county would realize through the years ahead, including businesses, banking and railroads. Is it she who is looking out the window, down to the street below to watch the world go by—a world that her descendants helped create yet she herself had missed?

Dougherty's Tavern became the private residence of Joseph Nicholson Jr., son of the Nicholsons who lived at the tavern that is now the White Swan and brother of James, naval officer. Later, the house was purchased by John Bordley and then William Barroll, representing yet two more very influential families of the region. (Changing houses seemed to be a favorite diversion among Kent County residents.)

Today, the Dougherty Barroll House, as it is called, continues to be a beautifully maintained residence. While no specific ghost has been reported, some who have lived in the house have indicated that some kind of a presence exists in the lovely old building. Nothing frightening, they say, simply a presence.

HISTORIC HOUSES OF CHESTERTOWN

A s the historical society prepared for our debut ghost walk, I began to suspect that there was some kind of a presence more often than not in the historic buildings for which Chestertown is known. I was conducting a training session for ghost walk guides along a block of Water Street that, with its stately brick homes, is as lovely as any residential street in this country. A charming lady stepped out of one of the houses, now condominiums, to chat with us. When she learned the reason for our stroll, she laughed.

"Oh, *we* have ghosts!" she said. "Or at least there's some kind of presence. Footsteps and sounds, all the time. But we don't mind a bit. It's really nothing."

Following are a few anecdotes from a sampling of some of the notable eighteenth-century properties in Chestertown that seem to retain "some kind of presence" along with a rich history that reflects centuries of Kent County heritage.

THE HYNSON—RINGGOLD HOUSE

This grand house on Water Street is owned by Washington College and served as the home for each sitting president since the 1940s. Figures of national and international prominence have been entertained there over the ensuing decades, leading the Hynson-Ringgold to serve, in a

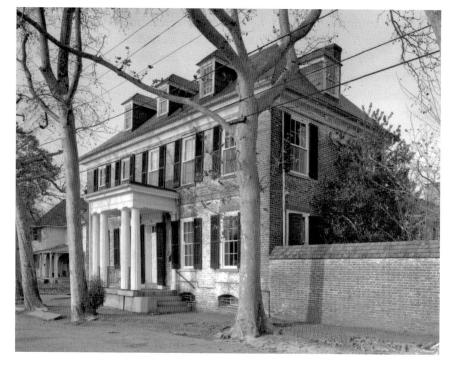

The Hynson-Ringgold House, circa 1742, serves as the residence for the president of Washington College.

sense, as Chestertown's welcome center for the wider world—and a very impressive one, at that.

But that is not a new role for the house, as in each century since it was built in the 1740s, it has held under its gabled roof the luminaries of every period. Wars, national enterprises and the very growth of the nation would have been discussed and planned within its walls.

The lot was originally purchased by Nathanial Hynson in 1735, but he likely did not build a house before he sold the lot, which shortly thereafter was purchased by Dr. William Murray, a Scottish-born surgeon. The house Murray built was essentially the same as the existing front section is today. Murray's sons were distinguished (Alexander, mentioned previously for his service in the Revolution, was one of them), and his daughters married into prominent families, so the house would have begun to see the activity and entertainments for which it would be known throughout most of its history.

In 1767, Murray sold the house and property, the latter of which was much more extensive then it is today, to Thomas Ringgold IV, descendant

of James Ringgold of the New Yarmouth enterprise. Thomas IV, who was one of the wealthiest men in Maryland, owned the country estate of Huntingfield and used what is now referred to as the Custom House as his town home and offices. He provided the Murray house to his son, Thomas V, as a suitable property for a man of near equal wealth and influence as his own. Both were members of the Maryland legislature and highly successful merchants and slave traders.

Under the Ringgolds' ownership, the house was expanded to create a mansion in the Georgian style far more impressive than any other residence in Chestertown at the time. It was during this expansion that an extension was added along Cannon Street that contained an enormous stair hall and the house's still notable antler stairs, ascending either side of the room to a landing and then continuing upward from there in the opposite direction. Cellars were also extended, possibly leading to the story that there was a tunnel connecting the house to the Custom House, but evidence for that has never been found. There was also a rumor that such a tunnel was used for the Underground Railroad, but considering that the occupants of the house were slaveholders and traders, that legend can be readily dismissed.

The Ringgolds entertained many distinguished guests, including George Washington, who stayed overnight at the house, as Thomas IV had done when visiting Mount Vernon.

Considering the massively complex intertwining of genealogies of the region's prominent families that ensured continued expansion of wealth and influence, suffice it to say that everyone who was anyone in that time would have dined, partied and likely slept within the walls of the Hynson-Ringgold House.

The Ringgolds' tenure at the house was brief, however, as Thomas IV died in 1772 and Thomas V in 1776. Both were buried on the property, although their bodies were moved at the end of the next century to Chester Cemetery.

The house passed through the ownership of the Spencers, distant relatives of both the Ringgolds and the Murrays (although just about everyone was a distant relative of some sort) and various others until purchased by lawyer James Edmondson Barroll (who was also a distant Ringgold relative through his first wife) and his second wife, Henrietta. On the Board of Visitors and Governors of Washington College for a quarter century, Barroll was known for his extensive library and edited, annotated and translated volumes of western literature. During the War of 1812, he served as secretary and adjutant of the Troop of Horse of Kent County's militia forces.

It was Barroll who named the grand house the "Abbey," by which everyone referred to it for the next century. And he was also the first to refer, at least in writing, to the Abbey's ghosts. They were primarily in the upstairs nursery, he said in a letter to a friend, but he himself had never seen them.

In 1853, the Barrolls sold the house to U.S. senator James Alfred Pearce (whose second wife was also a Ringgold, of course). Pearce was regent of the Smithsonian, the Library of Congress and the Botanical Gardens. It was said he played chess with Daniel Webster. Formerly a member of the House of Representatives, Pearce played a long and influential role in pre–Civil War politics.

Pearce was known as an accomplished and pragmatic politician, without color or flair but adept at getting things done, including drafting the "Pearce Plan" that resulted in the Senate's finalization of the Compromise of 1850, regarding the free or slave status of territories obtained after the Mexican-American War. Part of the Compromise was the Fugitive Slave Act, which mandated that authorities and citizens in free states had to assist in capturing supposed escapees, that people claiming to be pursuing an escapee did not need to produce any evidence, and that no person accused of being an escaped slave could testify on his own behalf.

Pearce, along with former U.S. senator Ezekiel Chamber also of Chestertown, was part of the local committee that, in 1853, decided to publicly tar and feather Quaker James Bower of Kent County and a free black woman named Harriet Tillison (fitting the description of Harriet Tubman, but no connection has ever been documented) for allegedly assisting runaways.

However, as the growing certainly of the Civil War approached, Pearce and Chambers joined other local leaders such as George Vickers and George B. Westcott in their opposition to secession. They understood that Maryland, as the northernmost border state, would be devastated if it seceded. However, they were also vehemently and vocally opposed to abolition.

Pearce died in December 1862, so he would have witnessed the beginning of the war and known that the Emancipation Proclamation was only a month away. Although the Proclamation did not apply to slave states not in rebellion, Pearce would have known, too, that the time was coming. Maryland would finally act to free its slaves in 1864.

Pearce was bedridden for a long period before his death. His bed was eventually bequeathed to the historical society and can be seen in the front bedroom of the Geddes-Piper House. Interestingly, one of

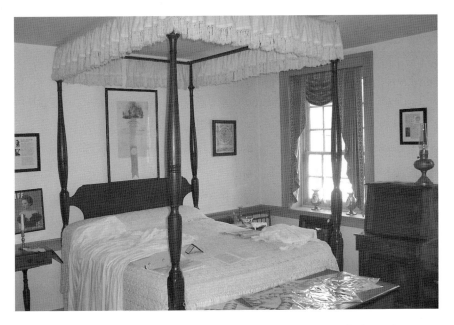

The bed of James Alfred Pearce from the Hynson-Ringgold House, on display at the Geddes-Piper House.

the "sensitive" people who visited there fixated on the bed for a long moment, before telling a staff person that a "man very troubled by issues of his day" had laid in the bed.

Upon his death, the house passed to his son, Judge James Alfred Pearce Jr., and then through various owners, including more Ringgolds, to become a boardinghouse and then a rental property. Among its tenants was a Mrs. Hynson, a descendant of the original owner of the lot. One of her daughters married Clifton Miller, who became president of Washington College's Board of Governors, a connection likely leading to the later use of the name for the house.

Stories of ghosts continued when the Catlins purchased the house in 1916, the first time in 150 years that there was no Ringgold connection to the owners. The maid of one of the Catlins' guests refused to sleep in her attic room because of invisible hands that kept touching her face while she slept. What other rumors there were is uncertain, but when I began working on the ghost walk, some society members with deep roots in Chestertown, who were very skeptical when it came to ghosts, would not hesitate to say, "Well, the Hynson-Ringgold House is supposed to be haunted."

After the house was purchased for the college by Wilbur Hubbard in the 1940s, it remained unoccupied during restoration, and various community members acted as custodians. It was common for local children to sneak into the house, looking for the ghosts. Elizabeth "Beppy" Bryan, former president of the society, was checking on the house when two boys crept in, so she hid on the upstairs landing. As the intruders cautiously made their way up the stairs, one said bravely, "I bet there's no ghosts."

"Oh, yes, there are," Beppy moaned, and off they ran.

Before I had heard that story, I was at a college reception at the house, standing in the great hall, looking up at the unique antler stairs. For one moment, I had a rare experience of feeling as if I was looking at a vintage photograph, as if the air around the staircase was somehow faded and grainy. If this place is haunted, I thought, its on those stairs. I then smiled at my own foolishness.

It is difficult to say whether I was surprised to read years later, in Elizabeth Duvall's *Three Centuries of American Life: The Hynson-Ringgold House of Chestertown*: "There have been other reports of the ghost, usually seen on the left side of the antler staircase."

Who knows? I can only think that if there is a ghost, it's probably related to the Ringgolds.

The Custom House

Built by Samuel Massey in the 1740s, this prominent four-story brick building was the largest building in Chestertown of that time. It would become forever associated, however, with its next owners, the Ringgold family, who used the building for their residence and offices. Space was leased by the Ringgolds to the customs inspector, whose offices may have been in the building itself or in a smaller building on the property.

Thomas Ringgold IV was a lawyer, businessman, merchant and slave trader, in business with his brother William and son Thomas V, influential in Maryland's colonial government and, before his death, in the Continental Convention. He was a business associate of Benjamin Franklin and a friend of George Washington. His extensive business dealings with his brother-in-law, Samuel Galloway of Anne Arundel County, helped spur the economy of Kent and contributed greatly to Chestertown's mid-eighteenth-century golden age as a focal point of colonial trade. From this impressive building,

which sat adjacent to the busy Port of Chester, Ringgold could oversee the activity of his mercantile enterprises, including the shipments of kidnapped slaves from Africa and convict laborers imported from England.

Until relatively recently, Ringgold and men such as him were referred to in traditional historic sources as simply "merchants," but the reality was that one of the primary commodities on which their fortunes were based was human misery.

Ringgold's letters to Galloway include complaints that the passage from Africa was so difficult that only one hundred or so of his cargo were left alive and fit to sell. Human beings, only weeks before torn from their families and everything they had known, were unloaded on the docks of Chestertown. Men, women and children, for the most part naked, would have been paraded in front of the sailors and dock hands, chained in the cellars of his offices and then dragged out to be presented to potential buyers or shipped across the bay to be sold in Annapolis.

"Men, women, boys and girls" were advertised in the *Maryland Gazette*. Children taken from their parents, husbands from their wives, people who would never see their loved ones or native land again. They might go on to bear more children, but those would likely be sold from them, too. It was not uncommon to see children as young as two advertised. By the nineteenth century, Maryland had become known as a "slave-breeding state," where slave owners could find as much or more profit in the sale of slaves as in their labor. With the shift from tobacco to less labor-intensive grain, there was a decreasing need for a large labor force. While some Marylanders freed their slaves, others found it lucrative to feed the growing market for slave labor on cotton plantations farther south. Although, at least it can be said of Kent County that it freed more of its slaves than any other Eastern Shore county, and by 1830, the number of slaves freed was three times higher than the number of slaves sold south.

Some slaves would find a pathway to freedom, such as Henry Phillips, who likely had been allowed to keep some of the money earned when he was hired out by Thomas Smyth. Just about the time the bells of liberty were tolling, Phillips was still putting aside money so that he could also buy his wife and son. Others would be freed when, in 1774, Quakers were urged by their brethren to give up their slaves. (It is also possible that some black people would have come into the region as servants rather than slaves, as sailors or simply as free people.)

But most of the Africans brought into port to be sold would never have control of their own destinies or that of their families again. Ringgold,

among his letters, offered commentary on what particular parts of Africa offered the most suitable captives; some groups of Africans were known for attempting suicide more readily then others. Other traders recommended taking the youngest, as they would be less bent on killing themselves out of despair than older people.

In my collecting of supernatural tales, someone once mentioned being afraid of ghosts.

"Why on earth would anyone be afraid of the dead?" I asked. "The living are frightening enough."

And, indeed, the actual enterprise carried out in the Custom House during the colonial period was far more ghastly than any ghost story I found about that or any other property. The only anecdote I came across about a ghost in the Custom House had nothing to do with clanking chains or human moans but, rather, a playful presence in the building. But a little more history of the house first.

Following the Ringgolds' ownership, the building went through various hands until it was purchased in 1805 by Simon Wickes, also from one of the county's oldest families, who owned it for several decades. James Alfred Pearce purchased it but lived there only briefly before he moved across the street into the other house the Ringgolds had owned. The house was then owned by the Brown family and used for apartments until purchased by the Hubbard family. In the 1970s, the inimitable Wilbur Hubbard Jr. donated the property to Washington College.

The Custom House was renovated to eventually house the college's C.V. Starr Center for the American Experience and the Center for Environment and Society. The offices are lovely, very much in keeping with the architectural heritage of the building. The ground floor of the building houses the college's archaeological laboratory, although the ominous gated vault in the old cellar was left intact. The vault possibly also gave rise to the story that there was once a tunnel between the two Ringgold properties. The vault would certainly have been used for storage of some sort and might have been used to incarcerate slaves before sale or transport, further adding to their fear and misery.

But again, the story told to me had nothing to do with fear or misery.

Portraits, prints and maps very appropriate for the Custom House's décor had been framed by the Finishing Touch, the excellent art store in Chestertown that has served the community for years. When two women from its staff arrived at the building to deliver and hang the pieces, they found it more challenging then they would ever have imagined.

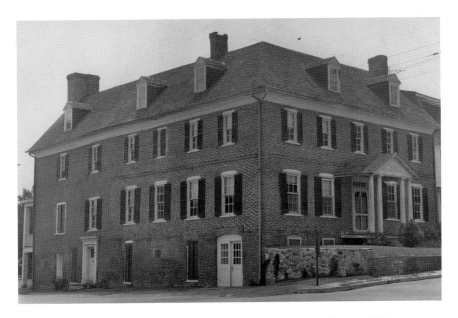

The Custom House served as the eighteenth-century offices and residence of Thomas Ringgold IV and now houses Washington College academic centers.

Each piece would be carefully mounted on the wall, but when the person doing the mounting turned around to reach for anther piece or a tool, she would turn back to find the artwork on the wall at an angle. Exasperated, she would straighten it again without looking away. Then a hand would tap her shoulder, and she would turn around—of course, no one was there—and turn back to see the artwork crooked again.

There were two women doing the work, and the same thing happened to each of them repeatedly. There was no sound, no scraping of the piece on the wall—just the invisible hand tapping them again and again on their shoulders. They tried working together, one watching while the other one hung the piece, but the invisible hand was so startling that it was almost impossible not to look away for the brief instant it took for the artwork to become crooked again.

Soon enough, their goal was to somehow get it done and get out of the building before dark. Eventually, the invisible and very unhelpful presence seemed to take pity on them or simply became bored, and they were allowed to finish their work.

WALLIS-WICKES HOUSE

The gardens of the Wallis-Wickes House were documented by the American Association of Garden Clubs in the early part of the twentieth century. There is perhaps no other landscaping feature in Chestertown as inviting as this; when one walks down High Street, it is almost impossible not to linger, looking in through the iron gate of the handsome brick walls, wishing to stroll down the paths through the gardens.

The large brick house was built in the late 1769s by the Wallis family, was lived in for a time by William Hands and Elizabeth Barroll and eventually became the home of Ezekiel Chamber's sister Elizabeth and her husband, Joseph Wickes. It remained in the Wickes family until the early twentieth century, when it fell to their heirs, the Burrells, who had previously resided at Rose Hill, the country home outside of Chestertown. It was Mrs. Burrell who created the gardens. In the 1970s, the Wickes House, as it had come to be called, was purchased by Eugene and Margaret Johnstone, who owned it into the twenty-first century. It must be noted that Mr. Johnstone was the editor, on behalf of the historical society of which he was president at the time, who worked with architectural historian and writer Michael Bourne to produce *Historic Houses of Kent County*. The book, now in its second printing, is an unequaled documentation, beautifully photographed throughout, of the architectural heritage of the county.

Because of the gated gardens, the house might seem, more than any of the other massive colonial homes, a world unto itself. Considering the stories I'd come to hear about other historic properties in town, I wasn't surprised to learn from an owner that, indeed, there was a presence in the house.

"I am not someone to believe in anything like this," the owner said simply (that he is a straightforward, pragmatic man, there is no doubt), but there is something unexplained in the house."

I went to the delightful Mrs. Johnstone to ask about it. After all, she had spent much of her life in the house and raised her children there.

Yes, there was a ghost, she told me, but she'd encountered it only twice.

Once, when her girls were little, Mrs. Johnstone was on the second floor, in the office at the back of the house. She heard the front door open and close and footsteps come up the stairs. Thinking that two of her youngest daughters had come home from school, she called their names, but no one answered, so she put down her pen and went out into the hall. Still, no one was there. She went upstairs to their rooms on the third floor and then down to the first floor. Still no one. Stepping outside, she asked the brick mason

working on the house (according to her, he not unexpectedly was kept quite busy in the neighborhood) if he had seen the girls. No, no one had come in or past the house. She went back in the house and looked again, certain that she had heard her girls.

It was not until hours later that the girls came home. They had stopped in the park to play with some of their friends after school and not come to the house at all.

The second time that Mrs. Johnstone felt there was a ghostly presence was when the guest of one of her daughters, sleeping on the second floor, awoke in the night and cried out. Mrs. Johnstone was the only one who heard her and went to the room, reaching for what she thought was the girl but touching nothing. She turned the light on to see the girl was sitting up in her bed, looking frightened and bewildered. She was certain that someone or something had been in the room. Mrs. Johnstone reassured her it was, indeed, nothing and sat with the girl while she drifted back to sleep.

Longtime neighbors matter-of-factly informed Mrs. Johnstone that the spirit's name was Charlotte and that she seemed to prefer haunting the stairs, particularly the window on the first landing that overlooked the garden. Whether she had ever been seen from the outside, Mrs. Johnstone was uncertain, but the neighbors were adamant that the ghost was named Charlotte.

Historic records indeed show Charlotte Spencer Wickes, widow of Thomas Wickes, living in Chestertown during the later nineteenth century. I couldn't ascertain if she had resided in the house, but obviously the neighbors felt she did.

Whatever the case, she seems to have chosen an excellent view to spend at least some part of eternity gazing upon. Interestingly, she was the third ghost I had heard of—the girl at the Geddes-Piper, the Victorian Lady at the White Swan and Charlotte Wickes—who had been seen looking out of a window. I would find out in time that this was a common pastime of haunts.

WIDEHALL

This extraordinary house that sits along the water across from the Custom House was built by Thomas Smyth in 1769. It was constructed quite likely using designs, if not craftsmen, from Annapolis or Philadelphia. Smyth purchased the lot from his father-in-law, Thomas Bedingfield Hands

(everyone's favorite historic name of Chestertown), and very possibly intended that he and his wife would have a grand town home to rival those of his fellow merchants and landowners. Smyth's own family property was Trumpington of Eastern Neck, constructed on the property that even by that early period had been in his family for a century.

Smyth was a very wealthy man at the time. Active politically, he had been county sheriff and, during the Revolution, was a member of the Council of Safety and personally financed the supply of wheat, flour, arms and vessels from his shipyard to the war effort. Following the war, he was forced to declare bankruptcy and began to divest himself of property. His brother-in-law, also Bedlington Hands, came to his aid and enabled Smyth to save Trumpington, where he returned to live until his death in 1818. He is buried there in the family cemetery.

Robert Wright, future governor of Maryland, owned the house briefly after Smyth's death and sold it into the Chambers family when he moved to Annapolis. It eventually became the residence of Ezekiel Forman Chambers, U.S. senator from Maryland and later judge of the Maryland Court of Appeals (and James Alfred Pearce's tar-and-feathering buddy).

Chambers, president of the Southern Rights Convention of Maryland in 1861, was an eloquent and energized defender of slavery in Maryland, pleading passionately until the end, which came with the revision of the state constitution in 1864, to uphold the rights of slaveholders. He commonly used the Bible to justify slavery and also the supposed reasoning that black people would die of starvation and want if the institution were to end. He might have known otherwise, as some of his neighbors, including Thomas Cuff, Isaac Boyer, James Jones, Levi Roger and Maria Bracker on Cannon and Front Streets, were free blacks with prosperous businesses that served both the white and black communities.

A different aspect of Chambers is revealed in an 1835 passage from his cousin Martha Ogle Forman's *Diary of Rose Hill*. Apparently, his wife had left him for someone else, for upon a visit to Widehall, his cousin wrote, "It was the most distressing scene I ever witnessed. The judge with his seven children around him, three of them infants. Oh my god, it was so heart rending, such trials make people die before their time. Of what material could a mother be made, who would desert her infant children, her husband, and everything comfortable around her and give herself up to infamy and wretchedness, for the sake of an abandoned man."

Fortunately for the sake of his children, Chambers did not die before his time. He passed away in Widehall short of his eightieth birthday in 1867.

George B. Westcott of the Geddes-Piper House purchased the property and leased it to the Brown family to be run as a hotel.

In the early 1900s, Widehall was rescued by Wilbur Watson Hubbard and his wife, Etta Belle Ross Hubbard, who had also purchased the Custom House and numerable other properties. Mr. Hubbard owned the fertilizer plant along the river. In the *Kent County News*, he was referred to as "that hustling manufacturer." As the Hubbards' private residence, Widehall was at last to be brought back to its full glory.

According to local accounts, Mrs. Hubbard became one of the first in Chestertown to decorate with period pieces, causing quite a stir throughout town, as this was before antiquing came into vogue. She and her husband created and maintained a grandeur that suited the house and was likely closer to Thomas Smyth's vision than even he himself had ever managed to realize.

Following their deaths, their son, Wilbur Ross Hubbard, reigned over Widehall, carrying on his mother's tradition of entertaining. An avid fox hunter all of his life, Wilbur was considered at his death to be the oldest master of the hounds in the world. Quite a character, he left his imprint in

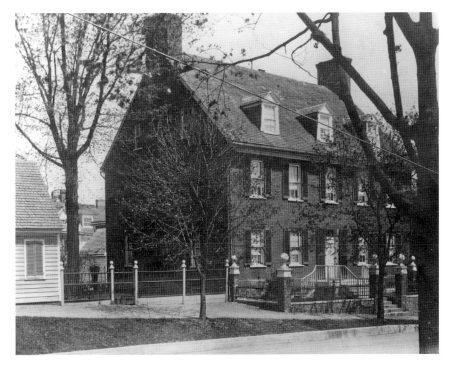

Widehall, the town home of colonial merchant Thomas Smyth, before restoration by the Hubbard family.

many ways on the fabric of the community. But his lasting legacy would be his efforts to preserve the historic buildings of Chestertown, including the Geddes-Piper House, the Hynson-Ringgold House, the Custom House and Widehall, incredible gifts to the architectural heritage of Kent County.

Wilbur Ross lived to be ninety-seven, and his last years were spent under the care of Tony Hurley, a professional caregiver and multitalented man with a deep sense of the history of the community. I had come to expect that almost any of these grand old properties had a ghost or two, and Tony's stories didn't fail me.

Mr. and Mrs. Hubbard, it seemed, each had their own private ghosts. According to Wilbur Ross, his mother's was that of an elegant colonial dame who sat outside Mrs. Hubbard's bedroom on the settee in the hallway. She wore a white pompadour wig and ball gown, the highest of fashions of another time. The colonial lady sat stiffly and silently beside the highboy and the candle stand, as if waiting for the ball to begin.

Mr. Hubbard, on the other hand, had always maintained that he saw the specter of a Revolutionary-era soldier occasionally standing at the foot of *his* bed. With a tricorner hat, braid and epaulets, he was decked out in all the accouterments of that heroic period, although, interestingly, he wore a red coat. Wilbur Ross said that on his deathbed his father had murmured, "Why is that soldier in my room?"

One frigid February night, Tony had retired to his small suite of rooms above the kitchen along with an out-of-town guest who was staying with him. They were suddenly awakened by a horrendous crash and sound of shattering glass, as if someone had dropped a tray of glasses and crystal on the servants' stairs. Tony grabbed a pistol kept in the house and told his friend to call 911.

There was nothing in the stairwell, so Tony went to the hanging stairs that led to the grand hall below. There was nothing there either, except a cold chill in a house that was usually kept as warm as an oven. Every hair stood up on the back of his neck. Sure that a burglar was in the house and had left the door open, Tony descended slowly. By that time, the police had come. An inspection of the house showed nothing, and the police left with the caution to lock the doors.

Wilbur had slept through it all.

Some months later, Wilbur's nieces came for a visit, and Tony told them about the crash. That's not the first time that had happened, they told him. Every so often, in the middle of the winter, a tremendous crash was heard coming from the backstairs. They'd been told it had to do with a story from Judge Chambers's time, when a servant fell down the stairs and broke her neck.

Wilbur himself was bedridden before his death, and Tony often sat with him through the night. One time, in the hours past midnight, Tony was half asleep in his chair when another sound, this time from the front of the house, awakened him. The front stairs creaked under footsteps, with each creak a thumping sound. *Thump thump, thump thump*, as if something was hitting the stairs with each step.

This time there was no friend to confirm that he was indeed hearing the sounds coming from the stairway. He rubbed his eyes to make sure he was awake, but by then, the footsteps were in the hallway coming toward the bedroom.

Wilbur stirred in his sleep, opening his eyes for a moment.

"Oh, it's that soldier and his damn sword," Wilbur said. "I see him all the time now, you know." He drifted off to sleep again, and the footsteps stopped.

The bed he was sleeping in, and in which he would soon pass away, was the bed his father had slept in when his personal specter would come to call.

RIVER HOUSE

The last great mansion to be built in Chestertown was River House. Immensely elegant, it is tall, with a full-windowed basement sitting at street level and two full stories and an attic rising above. Of all the wonderful old houses in Chestertown, it is one that, like a ship, is most naturally referred to in the feminine and so it is appropriate that its ghost is the "woman in white" (not to be confused with the ghostly character from the Wilkie Collins novel).

Thomas Smyth purchased the property for his son, Richard Gresham Smyth, in 1784. The junior Smyth in turn sold it to Peregrine Letherbury for a vast increase in sum, so it is likely the grand house was built by the Smyths.

Letherbury was a highly successful solicitor, a major in the Continental army, the first professor of law at Washington College and a grand master of the Masons. He resided at River House with his mistress, Mrs. Margaret Avery, a great scandal at the time, for which he was called before the Chester Parish Vestry but refused to appear.

Their daughter Mary was the heir to his fortune. She was born at River House, but she and her husband, George Washington Thomas, resided at Airy Hill. Mary read law to her father when he became blind and was remembered for freeing her slaves years before the Civil War, paying

them an income for their work and banking funds for their future. Even though married, she apparently retained her own fortune, made her own investments and financial decisions and left her wealth to her own heirs. This offers some indication that her mother's decision not to remarry might have been a financial one and that Mrs. Avery might have been pragmatic rather than wayward. In any case, they were both women before their time.

The house passed through Mary's heir, her cousin Peregrine Letherbury Wickes, and then to his brother, Ezekiel Chambers Wickes (one wonders how anyone kept names straight back then). It was then purchased by a Hynson and then the Browns.

After being widowed, Mrs. Brown lived in the house for several decades. In 1941, the house was sold to Frances Denton, secretary to Edward House, Woodrow Wilson's advisor; it was she who named it River House. Upon her death, it became the property of her niece, Marion Weeks, who bestowed it to the Maryland Historical Society in order to ensure its preservation. Irma and Karl Miller lived there for some time under the trust's ownership. During their tenancy, the interior of River House was restored and decorated exquisitely; a decorators' showcase of the mansion was used to raise funds for the publishing of *Historic Houses of Kent County* by the historical society. The trust then sold the house to Linda and Peter Sturtevant, returning it to a private residence.

River House was a frequent and favorite feature of the historical society's annual Historic House Tour. At just about the time we were planning to have the ghost walk, one of the ticket holders for the tour returned to the Geddes-Piper House and asked to speak to me, as the director.

"I know this is strange," she began in the familiar tone that led me to understand where the conversation was going to go, "but the house called River House, is it haunted?"

I could reply only that I had no idea.

"I can tell when a place is haunted," she continued. "There's the ghost of a woman—a woman in white—who brushed past me on the stairs. It was as if she was pleased we were all there and wanted to greet us. I just thought I'd mention that, as it really added to the tour."

Rather wishing that we had a ghost as a greeter at every house, for we would surely have made a fortune, I asked the owner, Linda Sturtevant, if she knew of anything unusual in River House. She herself had never seen or heard anything, but her housekeeper repeatedly said she had seen a woman in white, usually coming down the stairs. Linda was chuckling about this with a former housekeeper who then said that she, too, had frequently

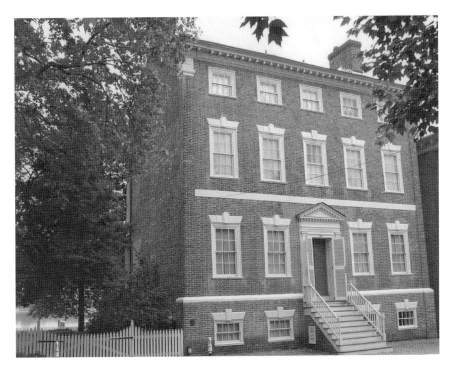

River House was the last grand mansion to be built in eighteenth-century Chestertown.

encountered the woman in white, but she seemed quite a ladylike presence and never bothered her a bit.

There are a number of candidates for the "woman in white" of River House: Mrs. Avery, her daughter Mary, Mrs. Brown, Miss Denton, Miss Weeks. Margaret Avery might have been determined to present herself as the rightful mistress of River House, regardless of local gossip. Mary Thomas, a remarkable woman for her time, adoring of her father, also deserved the title of lady of the house. Mrs. Brown had resided there quite awhile, and Miss Denton and Miss Weeks had clearly been devoted to the grand house.

Linda Sturtevant said she always liked to think the ghost is Mrs. Avery, as have others who've heard the story. (It is delightful to hear very knowledgeable people discuss the possible identity of a house spirit.)

Whoever the "woman in white" was, she made an excellent docent for the house tour, at least for the sensitive woman who was thrilled to be greeted by a genuine ghost.

MAGICAL OBJECTS

G hosts and the spirits of the dead have been included in the record of human activity throughout history. Ancient Egyptians, as we well know, made preparation for the afterlife an elaborate ritual, and it was felt that the spirits of the dead could continue to interact with the living. Romans categorized the types of spirits that could exist beyond death, although there became a fine line, as there is today, between literary tradition and actual acceptance of the ghostly return of the departed to earth. Still, almost every early culture entertained a belief system in which the spirits of the dead could be called on to either assist or hinder the living.

As the Christian era began, St. Augustine did his best to put a stop to the idea that the souls of the dead could return to earth and stated that the manifestation of any such images were either saints, angels or demons. In Europe and the British Isles, the church took measures to counter widely held superstitious beliefs and practices, taking drastic action against witchcraft in particular, from the medieval period into the eighteenth century.

But of course that didn't suppress the continued belief in a world of spirits and the use of rituals and magical practices to protect individuals and homes from harmful entities and to attract and appease helpful, protective ones.

Belief in ghosts, spirits, fairies and other supernatural beings accompanied immigrants from the British Isles and Europe to America and persisted well into the twentieth century. The forced immigration of Africans, later mixed with Caribbean influence, contributed to the melting pot of superstitious practices in the Mid-Atlantic.

A relatively widespread magical practice in Great Britain and Europe pertaining to belief in spirits was that of deliberately concealing objects within houses, often around the thresholds and hearth, for those were entrances and therefore the weakest points in the house.

Commonly concealed objects were footwear, usually one shoe or a piece of a shoe. There is no clearly documented reason for the concealment of shoes, although it is supposed that they are either to protect from malevolent forces or to bring good luck and prosperity. From European and British fairy lore there is an association with elves and house spirits with articles of clothing (as Harry Potter fans have come to realize), particularly shoes, stockings and cloaks. Some folk traditions have it that fairies and domestic spirits can be repelled by a gift of clothing; others state that they welcome it. And, of course, there is the very popular belief that if stockings and, in some cultures, shoes are left out, a benevolent spirit will leave gifts in them.

In German folklore, shoes have been said to repel bad fortune or even witches. In African lore, shoes and pieces of footwear of family members kept secreted in a house will bring good fortune, although there is a possibility that this superstition was adopted from the British and European traditions. One supposition is that a single shoe might keep the spirit of the wearer, if deceased, close to the home and family but that if two shoes were hidden, the spirit would be free to wander.

Another object representing a well-documented folk ritual from Britain and Europe are "witch bottles," constructed to counter a bewitchment. Bottles or, indeed, containers of many kinds could contain a variety of materials, including pins, nails, hair and urine of the person bewitched. Bottles and other containers are similarly used in the practice of Afro-Caribbean conjure.

Dolls or any type of human-like figurine, called "poppets," were used for magical purposes in British, European and Afro-Caribbean traditions. Often, they were used to cast a spell or curse, as we think of the purpose of a voodoo doll.

In *The Material Culture of Ritual Concealment in the United States*, M. Chris Manning shares contents of a nineteenth-century note tucked into the skirt of a poppet found in the brick walls of a house in Hereford, England: "Mary Ann Ward, I cast this spell on you, from my holl [*sic*] heart, wishing you to never sleep the rester [*sic*] part of your life. I hope your flesh will waste away and I hope you will never spend another penny I ought to have. Wishing this with my hole [*sic*] heart."

One presumes the writer was not Mary Ann's BFF.

I had the pleasure of speaking with Chris Manning over the telephone when she was doing her research on concealed objects for the above named

article. I was unfamiliar with the term until then but immediately knew what she meant, as I had heard of homeowners finding odd items that had been deliberately and secretively placed in various parts of their houses, revealed only when work or restoration was undertaken.

Following are a few examples, and once again, I take the liberty of adding a dose of history to each:

Hebpron Farm near Stillpond was established in 1713 by the Quaker family of the same name and sold in 1720 to the Corses, also influential Quakers. The Catholic Calverts had originally planned a colony based on religious freedom, as opposed to the Massachusetts Bay Colony, which was originally exclusionary of all but those with a very restrictive Puritan view of religious authority and worship. This open-door policy to other religions attracted a number of Quakers to Maryland, and they were among the early settlers of Kent County (unfortunately, Catholics were later discriminated against by the Protestants).

It was not until 1770 that the Corses built their house, a very impressive two-story brick house with a kitchen wing. Beautiful paneling on either side of the fireplace in the dining room was temporarily removed during a restoration project in the not-too-distant past, revealing two hidden cupboards. Inside were a tin filled with seeds and a child's shoe, hidden on a concealed ledge behind the chimney hearth, along with a small trapdoor that led to a tiny cramped room above the fireplace and cupboards.

The owner conjectured that the tiny space might have been where slaves or servants slept. But John Corse and his wife, Cassandra Rigby, had freed their slaves in 1774, and Mrs. Corse was known for her work among black people who had been set free by other Friends. They had sold their home to John J. Bowers, whose family lived there during the Civil War period. Bowers was also a Quaker and very possibly a relative of James Bowers who was tarred and feathered for assisting runaways.

So, it is indeed possible that the cramped space was used for hiding escaped slaves, although there is, to my knowledge, no documentation of that. But in that case, a child's shoe, coming from English tradition or adopted by African folk practices, might have offered a small talisman of protection for those hidden in the cramped chamber. Seed packets have also been found concealed in English houses as a talisman of protection or appeasement.

At Hodge's Bar near Rock Hall, the 1770 house was restored by Dr. Davy McCall, a revered local historian and former chair of the Economics Department at Washington College. Davy found whiskey bottles, a stoneware jar and a woman's single slipper concealed under floorboards in one of the

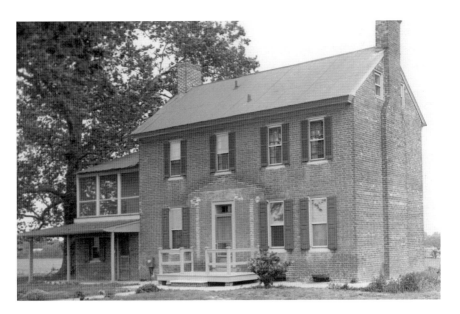

Hepron before restoration.

closets that are on either side of the hearth. In the closet on the other side of the hearth was a ladder up to a trapdoor that opened into the attic. When Dr. McCall's niece and her family were visiting, they heard the trapdoor repeatedly open and close, followed by footsteps in the attic when no one was there.

He eventually had the trapdoor removed, but it didn't stop the sound of it opening and closing, nor the footsteps walking across the empty attic. Workmen in the house often paused to ask who was in the attic, for they, too, could hear the footsteps. Several visitors reported seeing a ghostly figure by the hearth, and Dr. McCall's niece's children mentioned "feeling something" in a small bedroom to which the door visibly opened and closed for no reason.

It is interesting to note that the restoration project revealed that the main section of the house had been brought in and placed against the section considered to be the newer part of the house, at the location of the haunted hearth.

Dr. McCall contributed greatly to local heritage preservation in many ways, most notably in his research on African American history in Kent County.

After Hodge's Bar, he restored a house in Chestertown that had been the home of Thomas Cuff, a free black man of whom there is no record that he was ever a slave. In the first half of the nineteenth century, Cuff was one of

the largest black property owners in Chestertown, purchasing the majority of the lots in Scotts Point and his house on Cannon Street. He maintained a life-long friendship with Peregrine Wroth, a local attorney, with whom he conducted various business transactions. During restoration of the Cuff House, a porcelain doll was found concealed under the threshold, along with a lady's slipper.

A short way from the Cuff house on the Front Street extension of Water Street is the residence of Tony Hurley. The best-known owner of Tony's house was Isaac Boyer, a free black businessman who purchased his property from Cuff. Court records show two back-to-back transactions made in Boyer's name in one day that were a poignant statement of marital commitment: the purchase of Boyer's wife, Emma, followed by her manumission by her husband, and the presentation to his wife of her freedom papers.

Cuff and Boyer were co-founders of the Bethel AME Church in Chestertown. With continued sales of lots by Cuff to other free blacks, Scotts Point became a center of African American life in Chestertown.

Tony also found porcelain dolls secreted beneath both the front and back door sills of his home and a single lady's slipper hidden in the eaves of the attic.

Both the Cuff and the Boyer houses had been owned by white people before their purchase. It is possible that either the white or the black residents

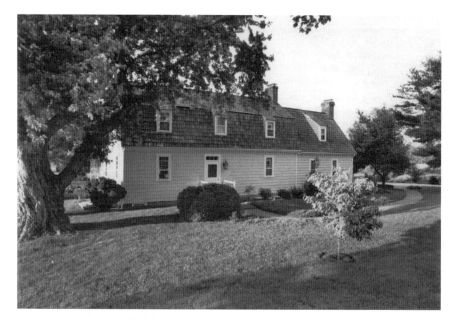

Hodges Bar following restoration.

Thomas Cuff House, home of an early nineteenth-century African American businessman.

Isaac Boyer House, home of a mid-nineteenth-century African American businessman.

of the houses concealed the dolls and shoes, but again, the original practices seem to come primarily from British and European tradition. In either case, they were placed there by someone who was brought up to believe that a little magic might serve a useful purpose.

Fanny Bergen, in her early twentieth-century collection of folklore, *Here on the Eastern Shore*, comments, "Of course, no dividing line can be drawn between the superstitions held by the Negroes and those of their white neighbors and employers, nor is it easy or even possible in many instances to ascertain the history of some interesting superstitions or myths."

The most unusual category of concealed objects that have been found or referred to in Kent County are animal skulls. Horse skulls have been concealed around thresholds of houses and barns in England, Ireland, Wales and parts of Scandinavia for at least several centuries, although magical belief in the properties of skulls goes back far longer in both British and Scandinavian traditions.

Fish Hall was the home of Edward Crew and his wife, Elizabeth Hanson, who, in 1778 settled on the bluff that later became Crews Landing and then Betterton. The tale goes that friendly Indians helped the Crews build on one of the most scenic locations in the county, overlooking the confluence of the Sassafras, Elk and Susquehanna Rivers. When Fish Hall was torn down in the twentieth century, it was recorded that horse skulls were found under the floor. The practice was apparently not so unusual in that it was immediately supposed they had been placed there "to keep the spooks away," as was mentioned in Fred Usilton's book *History of Kent County*.

Godlington Manor on Quaker Neck was built circa 1740 on a 1659 land grant and became one of the rare Kent County homeplaces that had until recently remained in the same family—the Miller/Merritt/Brown family—for three centuries. When well-known architectural historian Michael Bourne was overseeing work at the manor, cattle skulls were found hidden above the ceiling over the front and back doors. It appeared they had been placed there when the house had been enlarged around 1800, although the skulls might have been removed during that work and replaced. A study of the skulls by a Williamsburg archaeologist indicated they had not been butchered in the usual way as they would have been for food but had been deliberately chopped down to fit into the narrow space above the plaster ceiling and under the floorboards upstairs.

I have heard from local contractors that horse skulls were uncovered in several other locations. As in Godlington Manor, the skulls were also described as being carefully removed during restoration and then replaced.

Godlington Manor before restoration.

These were all impressive properties when they were built, dwellings of wealthy, landed people, as was the case with Fish Hall. So the tradition was by no means the practice of only middling or poor people, to whom superstitious beliefs are usually attributed.

Although Afro-Caribbean folk traditions have to have been part of the fabric of Kent County culture, none to my knowledge has been documented. Various people, black and white, have discussed Afro-Caribbean influence on agricultural practices used in the black rural communities, but these have never been fully explored. I have come across only one tale, called "The Graveyard Snake," in Robert Allan Gorsuch's 1970 published folklore collection *Ghosts of Kent County*, that specifically reflects Afro-Caribbean magical practices.

A man who lived in Church Alley when it was an African American neighborhood told Mr. Gorsuch that his father had been ill with joint pains, so much so that he would sometimes lay on the floor immobile. At the same time, there was a mysterious rapping in the house: four times in the middle of the floor, then four times in each corner of the house and then back to the middle again.

A local woman who heard of his misery approached him and said that he had a "graveyard snake" in his house. She gave him a bag that contained herbs and told him to wear the bag for three days, and the pain and the graveyard snake would be gone. He did as he was told, the pain left his body and the noise stopped.

I did some cursory research to find that a graveyard snake comes from the tradition of hoodoo lore, a mixture of African, Caribbean and European folk

beliefs, and American botanical lore, also referred to as conjure. The snake appears to be a malevolent spirit that (naturally) lives in the graveyard but can come into your home, and the pouch and herbs are a charm to banish it.

The bag the woman instructed the man's father to wear might actually have been "practical magic," similar to an asafoetida bag, which contained a variety of herbs, sometimes garlic and onions, along with asafoetida, a fennel-type plant also known as "devil's dung" because of its dreadful smell. It's a remedy for a number of ailments and was at one time commonly used by both black and white people, although it fell under the category of "slave medicine." Local people recall it being worn within the white community in Kent County, particularly throughout the fall and winter months, and remarked that even if it didn't ward off germs, it would ward off anyone who had them.

Another category of folk tradition that I have heard of being practiced in Kent County at least a generation ago is powwow, a primarily Pennsylvania German practice combining faith healing and magic. Powwow practitioners, or "hex doctors," were sought out for everything from curing warts to warding off a curse.

The use of magic to ward off the things that "go bump in the night" has been part of every cultural tradition for millennia into modern times. While it is interesting to muse about these superstitious practices, it is even more compelling to consider that the practitioners may have had a good reason for employing them. While I remain uncertain about what I think actually accounts for the strange sounds, ghostly images and unusual occurrences in so many of the properties in Kent County, of this I am certain: the people who shared their stories with me directly were describing a genuine experience.

I doubt whether horses' heads or poppets would have kept the footsteps out of the attics or the ghostly figures from the stairs, but it's interesting to think that for centuries, many people of Kent County thought that it was worth a try.

A walking stick presented to the historical society as a "spirit stick," useful in warding off harmful entities.

CHAPTER 6
THE WAR OF 1812

In the early morning hours of August 31, 2014, Major General James Adkins, the commander of the Maryland National Guard, and Colonel Alan Litster, the Royal Marine attaché at the British Embassy in Washington, laid a wreath at a monument sitting along the edge of Caulk's Field Road not too distant from Rock Hall. Beneath the field that spread before them laid the bodies of British soldiers who died at the Battle of Caulk's Field, exactly two centuries earlier. In a few hours' time, the field would be filled with battle cries, the explosion of gunpowder and the movement of troops in the reenactment of the climactic encounter that ended when the Kent County militia successfully routed the British.

The Battle of Caulk's Field was a small but meaningful victory for the young country, which had only weeks before been humiliated when the British captured the nation's capital. Looking back, many like to think that the actions of the Kent County militia served to inspire the beleaguered American forces, who within weeks would defeat the British at the Battle of Fort McHenry.

There, while watching the bombardment of the fort, Francis Scott Key would pen the words to the song that captured a pivotal moment in history. Later his words would be put to the tune "To Anacreon in Heaven," an old drinking song selected, as some sources have it, by Key's brother-in-law, Joseph Hopper Nicholson, whose grandfather had owned the tavern that is now the White Swan in Chestertown.

Although referred to as the "Forgotten War," some of the most exciting moments in U.S. history occurred during its course: Admiral Oliver Hazard

Reenactment of the Battle of Caulk's Field Bicentennial, August 31, 2014. *Courtesy of Kevin Hemstock.*

Perry's naval victory in Lake Erie aboard the USS *Niagara* ("We have met the enemy, and they are ours"), the British invasion of Washington and Dolley Madison's rescue of the portrait of George Washington, the Battle of Fort McHenry and Andrew Jackson's victory at New Orleans.

The same could be said of Kent County. Great local emphasis has traditionally been placed on the Revolution and the Civil War, yet while planning events for the War of 1812 Bicentennial, committee members were asked more than once, "Now, when was it?"

Yet the War of 1812 was the only war actually fought in Kent County. The county's shores were bombarded, homes set ablaze, livestock confiscated, property destroyed and residents frightened during the summers of 1813 and 1814 as Rear Admiral George Cockburn terrorized the Chesapeake.

But as with the nation at large, the War of 1812 gave little Kent County the chance to demonstrate that it could stand up to the British. Under the leadership of their own Lieutenant Colonel Phillip Reed of the Twenty-first Regiment of the Maryland Militia, Kent County men proved they were not about to be bullied. Imagine, if you would, the British invaders arriving on the shore, and local men shouldering their muskets, mounting their horses and marching out to meet them *and*

impressing the British and the rest of the country in the process. Well, that's what happened in the War of 1812. I hope the reader will forgive me as I go a bit overboard on history here, but this was decidedly one of the most exciting chapters in Kent County's past, and one about which too little is commonly known.

Kent County in the early nineteenth century was no longer a primary route of travel or a center of trade. By the 1800s, goods and produce were transported to Wilmington or shipped to Baltimore. In essence, the Eastern Shore had become a backwater. There was continued prosperity, but nothing like the glory days.

Joseph Scott's 1807 travelogue said of Chestertown, "It contains 140 houses, 41 of them brick, several of them built in a style of elegance…the public buildings are all of brick. No town on the Eastern Shore possesses so many local advantages…abundance of excellent water and a fertile, well cultivated surrounding country, but the proximity of Baltimore has monopolized the trade of Chestertown."

Despite Kent County's new era of isolation, local farmers and residents would have felt the impact of events leading up to the war.

American trade had been severely hindered by war between England and France; neither respected the rights of the United States as a neutral nation. It was difficult to ship from Baltimore, in spite of the boldness of its privateers, and this, in turn, affected Kent County farmers. The British practice of impressment was particularly troublesome to the United States. In need of seamen, they forcibly stopped and searched American vessels, taking sailors they claimed to be British citizens whether they were or not.

The two political parties, the Federalists and the Republicans, were divided over the possibility of war. The Federalists, the party of John Adams and, philosophically, of George Washington supported a strong national government, ties with Great Britain and the political leadership of men of property and experience. The Republicans opposed a strong alliance with Great Britain, feeling it would keep the United States dependent, and wanted the expansion of popular participation in politics.

However, when it was proposed that Maryland drop property requirements for voting, Republican Joseph Hopper Nicholson (of the Chestertown Nicholsons) declared that was as foolish as allowing women to vote. Republican leaning as the upper Eastern Shore was in the early part of the 1800s, the men of influence in Kent County continued to be those of property and wealth, even as Maryland dropped property requirements for white men to vote in 1810.

Republican War Hawks, led by Henry Clay and John C. Calhoun, were tired of being pushed around by the British and railed against their presence in the Great Lakes region, their alliance with Native American military leader Tecumseh and his threat to the new American frontier. Federalists advised that the U.S. army was ill prepared, the navy too small and war too costly. (They were right on the first and third points.)

The Declaration of War in June 1812 was the closest vote on any war in U.S. history. Due in part to the incorrect notion that Canada might wish to be annexed, the first engagements were along the border. Both the army and militia were unprepared and humiliated by the highly trained British regulars. The U.S. Navy, however, would prove itself the equal of the British Navy, considered the finest in the world.

The citizens of Kent County would not feel the full impact of war until the spring of 1813, when the British turned their attention to the Chesapeake.

In April 1813, British Rear Admiral Cockburn's naval forces reached Kent County. They attempted to land at Stillpond Creek but were repulsed by the local militia. Shots were heard across the bay as Howell Point was bombarded, terrifying residents. The British finally landed at Plum Point to plunder until driven off by local militia.

Cockburn continued up the bay, kidnapping James Stavely at Turner's Creek to pilot the British up the Sassafras to Georgetown, then a bustling village of forty houses and a shipyard. Cockburn sent warning that the town would be spared if it didn't resist. But their militia opened fire, only to flee as the British advanced, with most of the civilians following to hide in the woods.

The British landed and began torching the town. It is difficult to imagine peaceful Georgetown with a warship firing on its shores, while soldiers marched through destroying everything before them, torching homes, barns, any structure, leaving a path of destruction in their wake.

Local legend has it that Miss Kitty Knight, a distinguished lady of the town, faced off against the British before they could burn the home of her elderly neighbor. Such might well have been the case, as newspaper accounts reported that several homes were spared at the entreaties of the women and the aged.

Cockburn returned to Turners Creek, dropped Stavely off, took supplies and left "the people of this place well pleased with the wisdom…on their mode of receiving us."

In August, the British attacked St. Michael's. A letter to the western shore read, "Chestertown must go if attacked, for we have not a sufficient force to

repel them." But the heat, mosquitoes and Talbot County militia forced the British out of the bay for the time being.

Admiral Perry's brilliant naval victory in Lake Erie, William Henry Harrison's defeat of the British at Detroit and the death of Tecumseh turned the tide of war. Americans rejoiced when Napoleon was defeated by the British and Russians in the spring of 1814, and there was some hope for peace, but Republicans felt otherwise. "We should have to fight hereafter," said Joseph H. Nicholson, "not for free trade and sailors rights…but for our national existence."

With Europe at peace for the first time in decades, England turned its fiercest attention to the Chesapeake. The primary targets were Washington and Baltimore, but the English were not done raiding the Eastern Shore.

Kent County militia leader Lieutenant Colonel Phillip Reed Reed stationed his men at the mouth of Worton Creek in preparation for an invasion. His officers included James Edmundson Barroll, Benjamin Chambers and his son Ezekiel Chambers.

The HMS *Menelaus*, under the command of Sir Peter Parker, a handsome young British officer, landed at Swan Creek on August 20, 2014, with the intention of raiding Rock Hall. At about this time, the British had captured Washington when the Virginia militia fled before them. But Kent County militia were prepared to stand their ground.

On August 27, Reed had his men cross and recross Eastern Neck on a scow, convincing Parker that the militia had a much larger force (one wonders about his powers of discernment). Nonetheless, the British set out to raid Fairlee but were met by Reed's men.

"They were extremely well mounted, smashingly dress'd in blue and long white feathers in their hats," recorded one British officer, adding, "This is by far the finest part that I have seen in America. The house was elegant." Congreve rockets turned the militia back, and the elegant house of James Lloyd (Big Fairlee) was burned.

The British moved on to raid James Frisby's farm at Great Oak Manor, although Mrs. Frisby convinced them not to burn the house. Four of Frisby's slaves left with the British; they would have been offered freedom and the choice of either resettling in Canada or joining the British Navy (it is worth noting that neither sides' navy or merchant vessels were segregated at the time and that blacks fought with distinction on both sides in every naval engagement of the war).

The British went on to destroy Richard Frisby's farm, afterward meeting "an intelligent black man who gave us information of two hundred militia

being encamped in the woods, distant half a mile from the beach," according to a British officer's journal. The information was inaccurate; the militia was nearly three miles inland. A midshipman later wondered why they listened to a man whose "sincerity in our cause was very questionable." Whether he was a slave or a free man is unknown, but the misinformation he provided lent help to the Kent County militia.

On the moonlit night of August 30, the British landed at Skidmore and began moving inland. Thinking they were intending to loot and burn, Reed prepared his men to strike. During his march, he realized Parker was deliberately seeking an encounter. He gave the order to countermarch and form on the rising ground of Isaac Caulk's field, with the artillery in the center.

Reed's pickets exchanged fire, alerting the militia. Parker advanced his men toward the Americans, who had taken their positions. As the British charged up the hill toward the cannon, Reed gave the order to fire, killing and wounding several British. Into the battle, the militia's ammunition ran low, and Reed was prepared to give the order to fall back, leaving troops to continue to fight while the others retreated. But before his order was given, it became apparent that Sir Peter Parker had been mortally wounded.

The British retreated, leaving their dead marines, but taking Parker back to the Menelaus. His body was preserved and shipped to Bermuda, where it would later be exhumed and returned to England for burial.

"Houssa for the Militia!" Newspapers across the country proclaimed a victory of the militia over British forces, lifting the morale of Americans far beyond the borders of Kent County.

For almost the two centuries since the battle took place, local legend had it that Peter Parker's body was taken to the nearby Mitchell House, pickled in a barrel by Kent County residents and sent back to England. This might have been confused with the documented story that Major Joseph Thomas Mitchell himself was taken by the British, suspected of being the commissary general for Maryland.

Nonetheless, the legend of Sir Peter Parker persisted, as did a certain presence in the Mitchell House, not far from the fateful battle.

THE INN AT MITCHELL HOUSE

In the dark of night above Caulk's Field, glowing orbs of light have been captured on film, floating above the rise where Reed's men awaited the

charge of the British. Some of the men under Peter Parker's command were felled in their tracks and left on the field to be buried by the men who had slain them. Far from home, far from family or friends, far from anyone who knew them, anyone who would have stood by their graves and wept, they lay buried in the field, the foreign soil turned year after year above them. A century later, a marker would be placed and, two centuries later, a wreath and interpretive signing, but that is a long, long time to lay in the earth forgotten.

Nearby is the Mitchell House. Like Caulk's Field, it has the sense of being protected, away from the main road, sheltered by the woods surrounding it. At one moment in history, it was the scene of tremendous chaos, as Thomas Joseph Mitchell was dragged off by the British, his horses shot and his wife left standing alone in the midst of devastation and loss.

Caulk's Field remains a private farm, owned by Tulip Farms and managed by Richard Van Stolk. Their careful stewardship of the field where the fateful battle was fought is to be applauded, as is their generosity in enabling a monument to be placed and a massive reenactment undertaken.

The Mitchell House is as charming a country inn as could be found. The early nineteenth-century brick home, a three-story manor house with a two-story addition and porch overlooking the lawns, shelters guests from

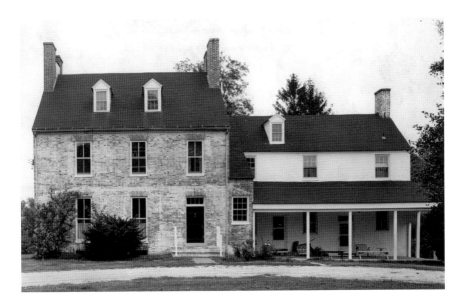

The Mitchell House (before restoration) played a role in the War of 1812.

the outside world. Inside, comfortable parlors, a kitchen and bedrooms with beautiful period pieces and historic architectural detail take visitors back in time. Owners Tracy and Jim Stone cherish their home and inn, and from the personal reviews posted on various travel sites, there is no question that they make all of their guests feel welcome.

But perhaps it's the house itself that also extends a welcome, as evidently someone or something was there long before the Stones came and has never gone away.

Tracy and Jim, who have owned the Inn at Mitchell House since 1986, are very accepting of the fact that there is a presence in the house with them. Like so many people with whom I've spoken about this type of phenomenon, they say the presence is nothing unsettling; it's simply *there*.

I first heard the stories when I served with Tracy on the War of 1812 Committee. Both the Stones are sincere history keepers and promoters, not just for the inn but also for Kent County in general. With the support of the committee, they organized an annual War of 1812 Weekend, along with a reenactment at the inn. It was certainly a lot more fun than the actual war, but it also enormously helped to promote this tumultuous but thrilling period in local history.

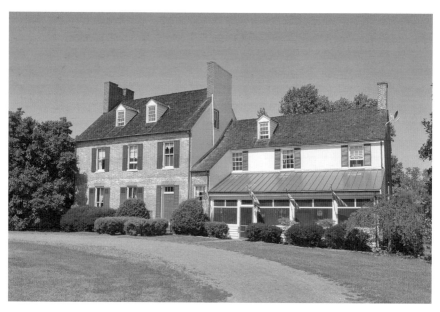

The Inn at Mitchell House following restoration. *Courtesy of Kevin Hemstock.*

Although the tales from the inn, at least on the surface, appear to have little to do with history, they are intriguing.

The Colonel Phillip Reed Room, for instance, is, like all the other guest rooms, a bright and airy space with a four-poster bed, fireplace and lovely detail throughout. Tracy mentioned that her dogs liked to play in there—in fact, they *really* like to play in there, as in, play with *someone*. Someone neither Tracy nor Jim can see. The Stones have two lovable golden retrievers (who also get good reviews on travel sites) that have never met a stranger. Even a stranger they've never met because the stranger is invisible. Both dogs enjoy going in the room and romping. As dogs do, they will put their heads down and hindquarters up, with tongues lolling and tails wagging, as if someone or something else was in the room with them.

The previous innkeeper had a basset hound who enjoyed the same activity in the Colonel Reed Room, although he was more prone to rolling on his back, as if someone was playfully pushing him over.

Cats, on the other hand, don't like the Colonel Reed Room at all. The Stones' first cat, Mr. Magoo, was king of the castle, but he would go no farther than the threshold before he would bolt. After Mr. Magoo's demise, two family cats have literally followed in his footsteps, going to the door of the room and then rapidly retreating. But perhaps whatever seems to be amusing the dogs doesn't like cats, either.

A rocking chair in the room used to rock for no reason, but the former owner had a very simple solution: he removed it.

Over the years, a few guests have asked if there is anything in that room, but the only feeling that they mentioned was that of something brushing against their legs. It led to the thought that there was a ghost dog in the room, a not unheard of phenomenon. It would certainly account for the distaste of the cats for the room; after all, two rowdy retrievers are enough. It would also account for the fact that guests never minded the presence, as there are few things more comforting than a loyal dog by your bed. Eventually, the retrievers' playmate became known as Gunner.

A knitting group that comes to the inn for an annual outing was sitting in the dining room after breakfast, the table still filled with dishes on which Tracy had served delicious French toast (also on the inn reviews: Tracy is a marvelous cook). One of the group members had brought along her husband, Walt. When Tracy returned to the room from the kitchen, the lady said, "You know, I was just telling Walt about the dog ghost. But I couldn't remember his name. Oh, yes, it was Gunner!"

With that, one of the footed water glasses on the table shattered, showering the dishes with glass. Tracy was so upset she even called Williams Sonoma to see if it had had any problem with exploding stemware. As one might imagine, it had not.

There was some precedent for glass shattering unexpectedly in the house. Previous to its life as an inn, the house had served as a nursing home for a time. The son of the owner, who had grown up in the house, was plucking and cleaning chickens in the kitchen when suddenly the glass in the window above the sink exploded, showering the chickens with glass. It wasn't as if the window had cracked—it had exploded, and there was nothing left of it. Of course, it ruined the chickens, and they all had to be thrown out. (One cannot help but wonder if that was a salmonella alert from the beyond.)

The only place Tracy has ever had an uncomfortable feeling in the house, however, is in a corner in the boiler room in the basement, where she has the sense that something is "there."

Years ago, it was locally accepted as fact that Sir Peter Parker had been taken to the Mitchell House and died there and that afterward, residents of Kent County pickled his body in a barrel and shipped it back to King George. Accompanying this story was the rumor that the house was haunted by the ghost of the British commander.

While that story was still popular, the director of the Maryland Office of Tourism Development had taken a journalist who was writing a travel piece about Kent County to the inn. They were sitting around the dining table in the evening. Tracy was giving an overview of the history of the area, but the writer seemed most curious about the tale of a locally pickled Peter Parker.

"Do you think the ghost of Peter Parker haunts the house?" asked the journalist.

Suddenly the light from the chandelier above the table where they were seated went out. Tracy rose to turn on the wall switch, but the light came back on before she had a chance to touch it. That was the first time that someone had asked Tracy about a ghost. The second time was the incident of the exploding Williams Sonoma stemware. As it turned out, there would be much discussion of ghosts in the future—and more unusual happenings.

Later, a filmmaker approached Tracy and Jim about a project he wanted to do at the Inn at Mitchell House. Although Tracy explained to him that the story about the locals pickling poor Peter was not true, the filmmaker remained fascinated by the legend.

Being good sports, the Stones welcomed the filmmaker and his crew, along with Rodney Whittaker, president of the Maryland Society of Ghost

Hunters, and his team. The filmmaker had invited the ghost hunters with the intention of filming their investigation.

I've had the pleasure of speaking with Rodney, who is a very level-headed observer of the unusual experiences that can occur on certain properties more often than one might expect. He and his team are careful collectors of information and travel to sites throughout Maryland for their investigations.

Rodney began ghost hunting by accident. Noticing an advertisement for what he thought was a ghost walk at a cemetery in Frederick, he and a friend decided that would be an entertaining way to spend a Friday night. It turned out not to be a ghost walk but a group of ghost hunters exploring the cemetery. Skeptical but game, he and his friend decided to go along anyway.

During the "investigation," however, he was amazed to see that other group members were capturing very unusual images on their digital cameras. Not just orbs and misty forms but also what appeared to be organic-looking tendrils that were, at least in the digital images, luminescent, draped over tombstones and wrapped around the wrought-iron gates and fence of the cemetery. He was captivated. The next day, he picked up a disposable camera, still common back then, and returned to the cemetery that evening. When he got the processed photos back, they showed the same bizarre phenomenon.

To this day, he is uncertain what the substance was. I viewed the images online, and the twisted tendrils are unlike anything I've ever seen, certainly nothing like pictures of orbs and other similar anomalies commonly associated with paranormal phenomenon. As Rodney stated, they almost look organic.

In any case, he was hooked and wanted to see what else he could find at cemeteries, historical sites and places supposedly haunted. He and other Maryland Society of Ghost Hunter members have an array of equipment used to capture audio, electromagnetic fields and other activity at a site. Some of their findings at various sites, and the experiences gathered from individuals who've asked them to investigate, are frankly very fascinating. However, the Inn at Mitchell House was the only site they'd investigated in Kent County when we spoke. Although it was some time ago that he'd been there, he did his best to recount the experience.

At the Mitchell House, the team arrived in the evening and went to work. On the first floor of the house, Rodney indicated there seemed to be a great deal of activity, as the lights on their electromagnetic sensors came on.

According to Rodney, it may take some time to make a connection and possibly communicate with whatever unseen presence is at a site. His method

is to place a flashlight on a flat surface where it can't be bumped or moved just by normal activity in the room. Before laying it down, he twists the top of it slightly so that it can be turned on or off with only a little effort. This is the system he used at the Mitchell House.

After speaking steadily, directly and quietly for several minutes, Rodney asked simply, "If you're here, can you turn the flashlight on?"

The flashlight turned on.

"Can you turn it off?" he asked.

The flashlight turned off.

That process went on for a bit, until he finally asked, "Are you Peter Parker?" indicating the flashlight was to be turned on if so. After repeating the question several times, in various ways, it seemed certain that whatever was turning the flashlight on and off was definitely not the ghost of the pickled Peter Parker.

In the basement of the house, Rodney laid the flashlight on the pool table, along with a K-2 meter that records electromagnetic activity, and began to ask simple questions. The flashlight turned on and off at his request, and the meter would light up when the answers appeared to be "yes." From the answers, Rodney guessed that the entity, or whatever it was, was female. It also appeared that the entity particularly liked one of the investigators named Dawn. (At the time of this writing, at least, this exchange can be viewed on YouTube under Maryland Society of Ghost Hunters.)

While Rodney was standing in the basement, he heard a clicking sound and realized it was the magnetic catch on his cellphone case attached to his belt. The little catch would lift up, then drop down, and the magnetic strip would click. That was repeated several times as he looked down, as if someone was playing with it, which made him think it was a younger girl or a child. The filmmaker had brought along a medium, and she said something about a serving girl with a broken back, but Rodney had no other basis for that information. The ghost hunters found nothing unusual in the corner of the boiler room where Tracy described a presence of some sort.

However, as the group turned to go back upstairs, they realized that pieces of wood and miscellaneous metal stored in the basement had been piled in front of the door of the boiler room, as if to block their way. No one had heard a sound.

The group returned to the dining room and sat down at the table to take a break. The lights were out and the recording devices on, but the gadgets weren't necessary to hear a very quiet voice say, "I want you da..." It was found later to have been recorded on the audio equipment, but all in the

group could actually hear it, including Tracy. There was some conjecture what the "da..." was.

"Dead"? Did it say, "I want you dead"?

Now, I am not a paranormal expert, that's certain, but there is nothing about the Inn at Mitchell House that makes it possible for me to believe any presence residing within would communicate that thought.

Rodney heard "Dad": "I want you, Dad." Tracy agreed that it did sound like that. "I want you, Dad."

Rodney said the experience was only the second time in his investigations that he had heard a voice without the use of the sensitive audio recording equipment.

The filmmaker and his crew put together a séance at the dining room table. Rodney didn't participate, presuming it was more for the film than any serious investigation.

While he was watching the séance from a monitor located in another room, he saw the tablecloth lift up slightly, as if something had gone under the table. None of the people seated at the table noticed it.

That night, Rodney slept in the Colonel Phillip Reed Room (the filmmaker had been offered the honor but declined). It was perfectly peaceful, but Rodney did awake once to see what appeared to be a woman or a girl standing by the window, looking out, as if waiting.

When Rodney and his friends went down the stairs the next morning, he and the investigator named Dawn, of whom the ghost seemed fond, were on the steps when they were pelted from above with wrapped chocolate candy that hit their backs and fell on the stairs. They went back upstairs to find that the source was a candy dish in one of the bedrooms, but no one else was in the upstairs rooms or hallway.

The only other detail that Rodney recalled was that the audio recordings taken in the Colonel Phillip Reed Room, when later listened to, contained an almost inaudible voice saying, "Hey, buddy," as if calling a dog.

That was the approximate account of the investigation of the house. The film, for various reasons, was never made.

So, if the haunting of Mitchell House was not caused by the ghost of Sir Peter Parker, as so many had believed for quite a long time, what was it in the inn that turned the flashlight on and off?

I looked up the etymology of the word "Dad," as we tend to think of it as a modern term. But it goes back to at least the year 1500. Would the spirit of a lonely little serving girl, after communicating with someone for possibly the first time in centuries, say, "I want you, Dad"? Had she slept in the corner

of the basement when she was alive? Perhaps lay there to die with an injury? Did she place wood and rods in front of the door so her new friends wouldn't leave and then pelt them with candy when they did?

Upon first hearing from Tracy that there was a presence in the Inn at Mitchell House, I couldn't help but think of the British marines, buried in foreign soil far away from everything they had known in life. It was sentimental, I realize, but nonetheless tempting to imagine lonely spirits seeking some kind of abode and finding the home of Joseph Thomas Mitchell's distressed wife, suddenly alone and very frightened herself. But such seems to not be the case.

If there *is* the spirit of a young girl tucked into the historic essence of the Inn at Mitchell House, then she would have had little to do with the tumultuous events and their nationwide impact that took place in the region at that time. Hers would have been an isolated life, set apart from the outside world, an existence that might seem unchanged after death (except perhaps for the companionship of Gunner the ghost dog).

There is no answer to any of this, only conjecture. Hearing Rodney and Tracy, both extremely credible observers, sharing their experiences at Mitchell House was when I accepted that there is such a thing as a genuine haunting. Not that I had disbelieved others who had shared their ghostly encounters—quite the contrary—but I had processed them simply as "good stories," which is how most of us are accustomed to hearing such anecdotes. We don't disbelieve, but we don't fully accept. But I had at last come to firmly believe and fully accept that when people say, "There's something in this house," that there usually is, indeed, something in the house. We just don't know what it is.

THE CIVIL WAR IN KENT COUNTY

A CONFLICTED SWORD

The War of 1812 was in some ways the official end of the colonial period and the beginning of the new era for America. But there was another great hurdle ahead for the country. For Kent County, it was one that would not be gotten over soon.

On the eve of the Civil War, Kent County had a population of 13,326—7,347 white, 3,411 free blacks and 2,509 slaves. In Chestertown, the number of free blacks equaled the number of whites. In other counties on the Eastern Shore (with the exception of Cecil, which had 950 slaves) and in southern Maryland, the number of slaves equaled or even exceeded the number of whites. Kent County was one of only three Maryland counties that had a free black population that exceeded its number of slaves.

Chestertown and Kent County had become accustomed to free black businessmen and women, tradesmen, artisans and laborers since the eighteenth century. As mentioned earlier, the so-called need for slave labor locally had declined with the introduction of less labor-intensive agricultural practices. Yet the majority of landed white leadership in Kent County remained firmly entrenched in their support of the institution of slavery.

While the value in real estate held by Kent County landowners was the highest in any Eastern Shore county, the contribution of slaves to the value of their personal property was not insignificant. In other words, even if

they did not "need" slave labor, slaves remained bankable assets. This is supported by the number of slaves (including Harriet Tubman) whose oral histories indicate that among the most tenuous of times for a slave family were when their owner died and individuals were sold off to settle debts of the estate or liquidate assets for division among heirs.

Local slaveholders joined those of the more southern regions in their continued protest of the assistance offered in northern states to runaways, as this was to them outright robbery of their personal property.

Many slaves managed to escape from Kent County. Most famous was Henry Highland Garnet, who had fled with his family as a child. He became an abolitionist and ordained Presbyterian minister and was the first black minister to preach to the U.S. House of Representatives. He might be considered the one internationally known man from Kent County in his time, as he was invited to lecture abroad. Known for his eloquent, forceful and often fiery rhetoric, he urged slaves to stand up to their white masters, even if it should lead to their death, and thereby distanced himself from Frederick Douglass (although Douglass mourned Garnet upon the latter's death). When the Civil War erupted, Garnet, along with Douglass, turned his attention to the founding of black army units and the recruitment of troops.

Also well known was Isaac Mason, whose free father managed to buy his wife and daughter but had insufficient funds to purchase Isaac and had to leave him behind when they traveled north. Isaac eventually escaped and made his way to Canada. In 1893, he published his memoirs, *Life of Isaac Mason as a Slave*, still in print today.

One of the most dramatic stories in local history was that of Harriet Shepherd. So desperate to rescue her children from the life that she had endured and determined that they would not be sold away from her, she boldly stole horses and two carriages from her master and simply drove out of Chestertown with her five young children and five other slaves. They escaped to Wilmington in November 1855 and eventually reached Philadelphia with the assistance of Underground Railroad conductor Thomas Garrett of Delaware.

(When I heard that people asked local historians what historical event might have led to the ghostly hoofbeats at night, galloping in the dark down High Street, I said, "Did you tell them about Harriet Shepherd?" But the specter of Tench Tilghman always got the credit.)

In the Geddes-Piper House dining room hangs a portrait of George W. Vickers. Like other Kent County men who had served as U.S. senators

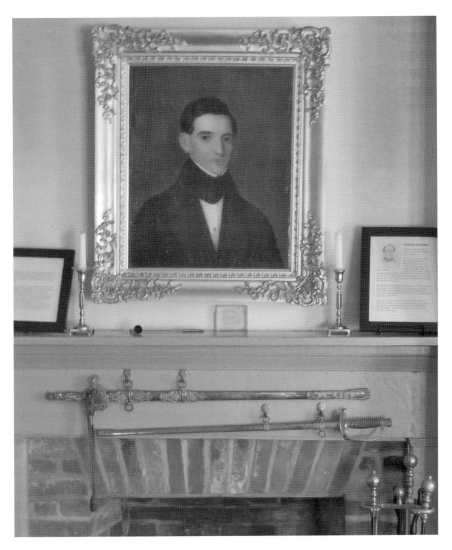

Portrait of George Vickers and dress swords at the Geddes-Piper House.

during the nineteenth century: James Alfred Pearce, James Ricaud and Ezekiel Chambers, he was an opponent of secession leading up to the Civil War but an equally vocal opponent of abolition.

The majority of leadership in Maryland counties understood that secession would be disastrous for the border state. As editorialized in the *Kent News*, "Our geographic position would cause us to be an arena of strife and deadly conflict."

Yet that same leadership could not imagine that they should be forced by the federal government to free their slaves.

Initially, Vickers was one of the more reliable "Unionists" in Kent County, although eventually, due to the slavery question, he would be among those considered "Conservative Unionists" rather than "Unconditional Unionists." He was appointed major general of the state militia. Camp Vickers, where local troops were trained, was named in his honor. His efforts helped Kent County exceed other Eastern Shore and Southern Maryland counties in recruitment of volunteers for the Union.

Vickers had four sons, two of whom fought in the war: one for the North and the other for the South. His son Benjamin joined the Second Tennessee Regiment and was mortally wounded at the Battle of Shiloh. On his deathbed he married his sweetheart, Sallie Houston, the niece of Sam Houston. His father eventually managed to have his body exhumed and returned to Kent County for burial.

Beneath his portrait at the Geddes-Piper House, two dress swords are mounted. One was that of Vickers, the other of one of his younger sons who was under sixteen when the war began. There is no record of his enlisting.

According to staff at the historical society, the woman who felt she could sense things by touching objects asked if she could touch the swords. (The staff person had been impressed when the woman touched the writing box of Dr. William Steele Maxwell of Still Pond, which bears no label, and said, "This man had so many interests and such a broad knowledge," which indeed had been the case.)

Running her hands lightly over the elaborate one belonging to Senator Vickers, she said nothing, but when touching the smaller, less ornate one belonging to the younger Vickers son, her hand stopped.

"This," she said, "belonged to a boy with mixed feelings about the war. He thought he had known his own mind and signed up, but when given the chance to run away and fight, he just couldn't do it. He stayed home, waiting to come of age, and was thankful that the war was over before he had to make that choice."

Regardless of whether or not the woman could sense things, it is certain that Vickers's younger boy would have had good reason to be conflicted. He had older brothers fighting on either side and a father who was torn between loyalty to his country, concern for his state and the defense of a system that was doomed for extinction if the country was truly to step into the modern age.

In battle, as in the debate over secession, the Civil War was truly brother against brother. At Culp's Hill during Gettysburg, the Union's

First Regiment Maryland Eastern Shore Infantry engaged the South's First Maryland Infantry CSA. After the battle, Northern commander Colonel James Wallace stated, "We sorrowfully gathered up many of our old friends and acquaintances and had them carefully and tenderly cared for." The Second Maryland Eastern Shore Infantry included the largest single number of Kent combatants, although Kent soldiers and sailors, Union and Confederate, white and black, fought with other units as well.

There was no conflict for men such as John Leeds Barroll of Chestertown. His newspaper, the *Kent Conservator*, referred to the North as "blood thirsty [*sic*] demons of abolition," and stated, "No authority exists in him [Lincoln] to interfere with the relation of slavery and the use of executive order to free the slaves." Of the Emancipation Proclamation, which authorized the freedom of slaves in the Confederate states (although not the slaveholding border states loyal to the Union), the *Conservator* declared that there was "no parallel or precedent in the history of the world since Adam and Eve left the Garden of Eden." Eventually, Barroll was arrested and forcibly sent South through the Confederate lines for the duration of the war.

And there was no conflict for the hundreds of black men from Kent County who escaped slavery by enlisting in the Union army. Steamboats from Baltimore would arrive along the shore to recruit both slaves and free blacks. Learning in advance of the ship's arrival, so many slaves flocked to the shore that some were inevitably left behind. Women also tried to join, without success, but boys younger than fifteen were often taken.

The recruitment of slaves of loyal Unionists enraged Vickers, who said of it, "No grosser violation of law, justice and Constitution was ever contemplated." He, George B. Westcott, John Ricaud and S.W. Spencer expressed in a letter to Governor Bradford that "want and partial starvation must be the inevitable result" of the loss of slave labor.

Eventually, he and others were able to have the practice halted, and Lincoln gave instructions that only slaves of secessionist-leaning slaveholders in the border states be recruited.

In April 1864, Maryland held a Constitutional Convention to which Ezekiel Chambers was a representative. Chambers railed to the end against abolition in Maryland, but a new constitution was drawn up and ratified (of all Eastern Shore counties, only voters in Caroline passed it by a narrow margin), and in November 1, 1864, slaves in Maryland were freed.

Some former slaveholders attempted to legally bind former slaves under the age of eighteen through "apprenticeship." When newly freed

slaves protested, the *Kent News* expressed surprise that "there is evidently a disposition among Negro parents to hold onto their children."

Lee surrendered at Appomattox Court House on April 9, 1865. One of the last soldiers to die during the war was Confederate private William Price of Kennedysville, who was killed just before the conclusion of the battle.

On July 4 of that year, for the first time in its history, there was no Independence Day celebration in Chestertown.

In a county that had long benefited from the participation of a thriving and productive free black population, racial inequality would sadly remain entrenched after the war.

An elderly resident of Kent County had a relative who, as a former slave, had witnessed the surrender at Appomattox when she was a child of nine. He recalled her saying, "I saw my freedom given to me that day and lived to see it taken away."

Following the Civil War, numerous incidents served to illustrate the racial tensions existing in Kent County in that era. Among them were the burnings of black churches and schools. In 1865, the American Methodist Episcopal Church in Millington, which also served as a school, was burned to the ground, and two weeks later, the African American church in Edesville was burned as well. Both black and white leadership were enraged. The governor of the state offered a reward for the apprehension of the culprits, matched by benevolent associations in Baltimore. It was determined by what appeared to be a legitimate investigation that the burning of the Millington AME Church was the result of a faulty flue, but the Edesville church was the work of drunken whites.

Following the initial outcry, Donald Meeks, county school board president, railed at Baltimore and New York papers for sensationalizing the fires, saying it was only intensifying local white prejudice against blacks. Another complaint from whites that Meeks had to respond to was that members of the black community who worked as laborers during the day were going to school at night and therefore would not be rested up for their work.

The Heighe Hill murder in late nineteenth-century Millington would also galvanize an audience far beyond the borders of the county, but for that story, I recommend to readers *Injustice on the Eastern Shore: Race and the Hill Murder Trial*, by Millington's own Kevin Hemstock (The History Press).

The Fifteenth Amendment to the U.S. Constitution, ratified in 1870, prohibited the denial of the right to vote based on race, color or previous condition of servitude. Vickers vigorously but unsuccessfully debated its passage with Charles Sumner in the U.S. Senate.

Chestertown quickly reinstated the property requirement for voting (propertied free black men could vote in Maryland until 1804, when that right was rescinded). Local black businessmen such as James Jones sold tiny plots of their property to other black men, enabling them to meet the voting requirements, which were later abandoned.

Shortly after the war, African American veterans of Kent County paid tribute to the fallen on both sides of the conflict by marching down High Street to decorate the graves of veterans. They were following the lead of their fellow "colored troops" of Charleston, who, in 1865, had started the tradition. The *Kent News*, somewhat begrudgingly, applauded their gesture. Those same men would form the Charles Sumner African American Grand Army of the Republic Post #25 in 1882. More than one hundred years later, a truly diverse community effort ensured its preservation. It is now on the National Register of Historic Places and one of only two remaining African American GAR Halls in the country.

BACK TO THE COURTHOUSE AND ON TO THE CHESTER CEMETERY

Following the war, former slaveholders did not starve, although their assets had been lessened. For white families who had had no slaves, life went on much the same, if their men had managed to survive the war intact.

There would have been very few families in Kent County who did not suffer loss from the devastating war. The first Civil War monument in Chestertown on Memorial Row lists many of the white men who served, with Union soldiers and sailors on one side and Confederates on the other. Decades later, a memorial to the hundreds of black soldiers who served was erected nearby.

Due in part to the casualties of the war, a new cemetery was deemed necessary in Chestertown in 1862. George Vickers donated land for the Chester Cemetery at the end of High Street. Through great effort, he retrieved his son's body and brought it back to Chestertown to be interred there.

Bodies from the graves at the courthouse cemetery were to be reinterred in the new one. But some bodies were left behind, including those of Vickers's parents; for whatever reason, he chose not to move them. Other bodies remained in the courthouse cemetery in graves that had gone to ruin and were unmarked or for whom no family members stepped forth to pay for them to be dug up and reburied.

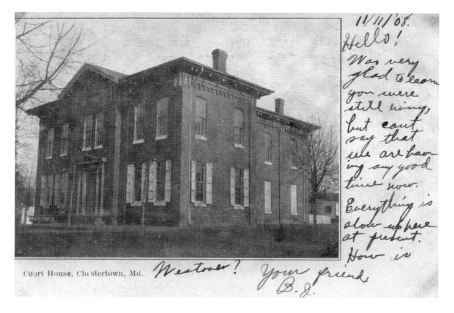

Vintage photograph of the Kent County Courthouse.

When the courthouse was expanded in 1969, employees and other observers said there were still skeletons found. When a parking lot was built some years later, there was the rumor that still persists that bones were found there as well.

The following was told to me by a former courthouse employee who worked the night shift at the 911 dispatch center some years ago when it was in the building's basement, in the exact ground where once the cemetery had been:

People come in and out of the courthouse all night. Lawyers would come and go at any hour, usually to use the library. They'd enter through the Cross Street door, cross to the stairwell, open and close the door and go upstairs. Once or twice a month, we would hear the footsteps, the stairwell door open and close, but when we turned the stairwell intercom on, there was no one in the stairwell. This would be a matter of seconds from the time we heard the footsteps and the door open and close, there was no way they could have turned and left the building, or gone upstairs.

The dispatch room was next to the conference room with a door connecting them. If the door was open into the dark conference room, anyone who worked there said they had an uneasy feeling, as if someone was watching. They only way to make it go away was to close the door.

One woman brought her dog to work, and it would growl at the door to the hallway until she closed it. Another man saw a mist go down the hall. None of the people who worked at night were surprised when the video monitor captured the mist on the stairs in 2004.

Everyone who worked in the dispatch center at night took notes, and all of them reported the same experiences.

Tony Hurley said that his neighbor Maude Boulden always told him that the area from the railroad tracks out toward the Chester Cemetery was referred to as "out the path." The road from that point on was dirt. She said that many times, whenever a horse and carriage had to go past the cemetery, especially late at night, the horses would often perk up their ears and act afraid, picking up the pace until they were past that spot.

The land that would become the site of the new cemetery was used for the hanging of the three men—Nicholas Murphy, William Shelton and Abraham Taylor—convicted of the 1852 mass murder of the Cosden family and other residents of their home outside Galena. The story of the murders far exceeds in horror any ghost story ever told.

Kent County Courthouse as it appears today.

Murphy's death added to the gruesomeness of the tale, as the rope broke once and he dropped to the ground. Although the second attempt was successful, he did not die immediately. In his struggles, his mask came off and the crowd that had gathered viewed his distorted face for eleven long minutes before he succumbed.

At the Chester Cemetery, friends of mine, intrigued by the stories we were collecting for the ghost walk, went on a hunt for orbs. Their likely motivation was to feel, for just an evening, as if they were back in high school, and they weren't disappointed. To their delight, glowing orbs floated above the headstones in the digital images they captured with their cameras. They had not expected their hunt to prove successful.

A man I know who grew up in a house next to the cemetery told the following story. His second-floor bedroom window looked out at the lights from the building across the street. As he lay in bed, more than once a shadow crossed the room on the inside of the window, blocking the lights for a moment. One time his bare foot was exposed, sticking out from the blanket at the bottom of the bed, and he could feel air brushing against it, as if something had moved past it.

In the living room of their house, while the family watched television, their dog would stare up at the ceiling, his head moving back and forth as if he was following something invisible, and then his head would drop to follow it out of the room.

One time there was a horrible crash in the attic, as if a pile of boxes had toppled, but when he and his father went up to see, nothing was disturbed.

In one humorous tale, the same man said that he and a friend were taking a shortcut through the cemetery at night when the nearby fire siren went off—almost. The mechanism hadn't completely turned, and the sound it emitted was a low, trembling groan as if the undead were emerging from their tombs. His friend was out of the cemetery and into the house within seconds.

(For detail of the Cosden murders, I refer you to *Haunted Eastern Shore*, by Mindie Burgoyne. Also included in that volume are the well-known Kent County tales of the ghost of Kitty Knight and of White House Farm.)

CHAPTER 8

THE VICTORIAN PERIOD

STEAMSHIP DAYS

This little tale was told to me by a member of the Westcott family. Family members were relaxing with company on their porch on Water Street when one of the guests shared a dream from the night before: "We were sitting right here when the steamboat whistle blew, and a little red-haired girl ran down the street and called out, 'Let's go ride the waves!' We all got into a rowboat and rowed out into the river in the wake of the steamship, and then we all drowned when the boat capsized."

Just as the guest finished her story, a little red-haired girl—a real one—came running down the street and called out, "The steamship's coming! We should all go ride the waves!" Needless to say, no one took her up on the invitation.

Major changes in transportation and technology transformed the economy, society and landscape of Kent County in the nineteenth century. In 1833, the Chesapeake became the first steamboat to cross from Baltimore to Rock Hall. The change from reliance on the wind and tides, and the ensuing maintenance of a regular schedule of trips across the bay, had a profound effect on the ability to transport produce, goods and seafood to a wider market.

The Chester River Steamboat Company formed in 1865, when Colonel B.S. Ford purchased the line of Henry B. Slaughter of Crumpton, who in

A steamship on the Chester River.

1860 had begun offering daily service along the Chester with the *Arrow*, the *Chester* and the *George Law*. The company prospered, and the *B.S. Ford*, *Corsica*, *Emma Ford* and *Gratitude* were added to the fleet, which stopped at Chestertown, Rolphs Wharf, Quaker Neck, Cliffs, Spaniards Point, Spry's Landing, Buckingham, Round Top and Deep Landing.

The Kent County Railroad Company was chartered in 1856, with George Vickers as president, although the first train didn't pull into Chestertown until 1872, delayed by the Civil War and lack of investors. The completed railroad was leased to the Philadelphia, Wilmington and Baltimore Railroad. Coming from the mainline at Townsend, Delaware, it made stops at Massey, Kennedyville and Worton before reaching Chestertown. Efforts were made to continue the tracks to the Chesapeake Bay, but that project was abandoned. In 1900, the line was purchased by the Pennsylvania Railroad.

With rail transportation available, enterprising farmers soon realized that products could be shipped overnight to Philadelphia and New York.

Kent County farmers were continually seeking ways to earn a living from their land. Many wheat fields gave way to orchards and, after a peach blight, to vegetables and berries. Truck farming, referring to trucking one's produce to market, even if the truck is a wagon or the market a wharf, began its development along the Eastern Shore.

"We can grow anything we have tried so far, on our land. Truly a good legacy for a man to leave his family," wrote farmer Evelyn Harris of Howell Point Farm in her incredible memoir of Kent County farm life, *The Barter Lady*.

Watermen of Kent County were no less versatile. They harvested a variety of produce from the bay and its tributaries: oysters, crabs, rockfish, shad, herring and striped bass. They moved about the bay, staying for weeks in fishing shanties, or "arks," when necessary, working the water throughout the year. Many came from a long tradition of hard-working, hard-living people too poor to buy land and too independent to sharecrop, but their day had finally come.

Buy boats came from Baltimore and picked up produce and fish at Kent County wharves along the bay and up the Sassafras and Chester Rivers.

Rock Hall became a major center of the seafood industry in the Chesapeake, a bustling hub of processing, canning and distribution, and it would continue in this capacity through much of the twentieth century. "The Rockfish Capital of the World" boasted several large retail establishments, including Hubbard's Pier, as well as numerous related industries. An estimated 80 percent of the residents, including their renowned watermen, worked in the maritime trades. (The maritime tradition continues today, although processing and distribution have been replaced with a focus on recreational boating.)

This early twentieth-century postcard shows the charm of Rock Hall's Main Street.

Canneries began opening in the 1830s along the eastern seaboard, creating the food preservation industry, of which Baltimore soon became the national center. Along with the steamboat and the railroad, this new technology completely changed the market for the farmers' crops and the watermen's catch. Canneries didn't open in Kent County until late in the century, the first in Still Pond in 1889, although the industry would never dominate the economy as it did on the lower shore.

Steamships weren't just taking commodities and passengers out of Kent County; they were also bringing them in. The tourist trade had begun.

The romance of the steamship era is exemplified by two Kent County resorts of the Victorian period. Betterton became a vacation spot in the 1850s, when Richard Turner built a steamship wharf at Crew's Landing. They renamed the town after his wife, Elizabeth Betterton.

Betterton boasted hotels and guest cottages, verandas with rocking chairs and a pavilion where couples danced and flirted into the night, all with a breathtaking view of the bay. All of this attracted the city dwellers to the "Jewel of the Chesapeake" well into the twentieth century, and they flocked across the bay by steamboat.

Tolchester Beach was begun in 1877 by father and son Calvin and E.B. Taggart and further improved by W.C. Eliason, who was hired as a company clerk but eventually became president. The resort had a roller coaster and miniature railroad and was the most beloved of all of the Chesapeake resorts. Visitors (white only; although black people worked there, the resort was segregated) were transported from the noise and crowds of the city into dreamland by steamboats such as the *Emma Giles*. When Tolchester Beach and the *Bay Belle*, the last steamboat in the bay with a regular schedule, were surrendered to mortgage holders in 1962, service to Betterton also stopped, and an era came to a close.

Today, Betterton's resort past is quietly echoed in its charming Victorian cottages and lovely beach. But Tolchestor Beach was dismantled; thankfully, many items were acquired by the late William Betts, whose collection can be viewed at the Tolchestor Beach Revisited Museum in Rock Hall. What could not be sold was bulldozed away, and all that remained of the magnificent resort were memories.

TIME SLIP TO TOLCHESTER

In the 1980s, Jim Maitland and his family lived at Tolchester Estates, near the location of the old amusement park. The only thing that remained of Tolchester Beach was the paved area where the main gates had once been.

Jim's son Kevin came home one August evening around dusk, looking as white as a sheet. Jim could tell the boy was distraught but couldn't get him to say what had happened. He talked to him gently until finally Kevin opened up and shared the strange experience he had coming home, when he'd taken a short cut through where Tolchester Park had once been.

Kevin said that when he got to the paved area where the gates had been, he started to hear strange sounds that began to grow, as if someone was slowly turning the volume up on a radio. Each sound seemed to come from a different location, but there was nothing there to make them. He heard people talking and laughing. From somewhere came the sound of shouting

Tolchestor Beach during its heyday. *Courtesy of Mark Newsome.*

like barkers do at carnival games. He heard machines and spinning wheels. From off to one side came old-fashioned music. And all the time he was looking at empty space.

The next day, Jim, who had worked at Tolchester Beach when he was a teenager, took his son back to the empty place. Together they stood, and Kevin told his father where each sound had seemed to come from. Jim, in turn, pointed out where the bumper cars had been, the roller coaster, the merry-go-round, the ticket takers—where the things had been that would have made the sounds that for some reason came out of time and reached the ears of the boy that August night.

MILLINGTON MANOR

The new methods of transportation for produce and continuing diversification of crops brought a quiet prosperity for Kent County farms and communities. By the early twentieth century there were five incorporated towns in the county: Chestertown, Rock Hall, Betterton, Galena and Millington. Worton, Fairlee and Kennedysville would become known as "water tower towns," as each community's population warranted water and sewage installations.

Kennedyville was among the stops when the railroad offered passenger service through Kent County. *Courtesy of Mark Newsome.*

South Church St., Still Pond, Md.

Stillpond in the early twentieth century. *Courtesy of Mark Newsome.*

Still Pond briefly incorporated from 1906 to 1920. In the articles of incorporation, the town became the first in Maryland to allow women to vote. Although fourteen women registered (two of them black), only three braved the trip to the ballot box. Among them was Annie Maxwell, the wife of Dr. William Maxwell, whose remarkable diary, housed in the historical society's collection, offers a very forward-thinking comprehensive documentation of rural life.

Kent County's little towns were bustling centers of activity. Millington, with its mills and businesses, surrounded by rich farmland, was a hub of agricultural commerce into the twentieth century.

Millington had its own rich colonial history. Daniel Toas operated a tavern and ferry crossing at what was then referred to as Head of Chester; his name appears in historic records from the late 1600s. The first bridge across the Chester was built there in 1724 (the bridge at Chestertown would not be built until 1820), leading to another name for the community: Bridge Town.

The town grew up around the milling industry. One of the original eighteenth-century mills remains, now used as a residence. Established by Thomas Massey, it was sold to Thomas Gilpin in 1767. Gilpin, who was one of a number of Kent County agriculturalists who experimented with innovative methods of farming, developed a mildew-resistant grain. A Quaker, he died in internment during the Revolution for refusing to fight.

Vintage photo of downtown Millington. *Courtesy of Mark Newsome.*

The town was a transportation hub for grain during the war. It was complained that wheat could not be distributed quickly enough, as the Marquis de Lafayette had impressed so many of the horses and teams in the area.

In 1818, Bridge Town and Sand Town in Queen Anne's County were merged and incorporated as Millington.

The post–Civil War era was a remarkable period for the community. Surrounded by farmland specializing in peach production and on the railroad line that connected to the northern markets, Millington offered farmers not only a distribution center but also an array of shops, services and social activities. Lovely Victorian homes were built as a testament to the town's affluence. Like so much of Kent County architectural heritage, many of them remain beautifully preserved.

One of these exquisite Victorian homes can be seen on the Kent County government's official website, under the section that promotes local locations available for filmmakers seeking historic settings. The house is referred to on the website as "Victorian Romance," and it is indeed a perfect example of the architectural charm of that time. Its historic name is Millington Manor, which certainly suits it as well, particularly after the excellent restoration work undertaken following an extensive fire and subsequently by the present owner.

The house was built by Dr. Enoch Clarke and served the town for a long period as a doctor's office and small hospital with a surgery, as was not uncommon into the twentieth century. Later, it was occupied by Dr. Ned M. Jeter and his family, who were occasionally mentioned in social news of the time; Dr. Jeter died in his home in 1912 at the age of fifty. Eventually, the house became solely a private residence.

When owner Dorothy, or "Teddi," Zia purchased the house, she simply thought she had bought the beautiful Victorian of her dreams—until she was having a cup of coffee at a little restaurant in Millington. Introducing herself to the waitress, Teddi didn't expect her reply.

"Oh, you bought the house we used to call the Bad Luck House when we were kids," the waitress said, pouring more coffee for the startled Teddi. "Dr. Jeter, who lived there long before I was born, died upstairs. One owner fell out of a tree in the yard cutting branches and broke both his legs, while another one broke both his legs, too, in an accident right there in the house.

Millington Manor following restoration. *Courtesy of Kevin Hemstock.*

"But the worst"—at that the waitress had to put her coffee pot down—"was the two little boys who died in a terrible fire. There was a fog delay at school, and their father and stepsister were downstairs making breakfast, while the two boys went back upstairs to watch TV in their parents' bedroom. There was a tear in the water bed, and it leaked down into the wiring, shorted it out and started a fire between the floors—can you imagine that? They said the little boys would have died of smoke inhalation before the fire ever got to them; at least that's a mercy. The father, the neighbors, then the firefighters all tried to get to them up the side of the house, but it was too late. All the pictures in the paper showed the firemen with tears in their eyes. More than one boy who watched that day went on to be a firefighter, so they could try to help if anything like that happened again. It was horrible, just horrible.

"The family packed up and moved after that, can you blame them?

"But even before that, when we were kids," the waitress whispered, "We could see faces in the house when it stood empty, looking out the upstairs windows. Can you believe that? We really did. Creepy." She picked up her coffee pot.

"But welcome to town! We are sure glad to have you."

Teddi is a tiny but very determined lady. She finished her coffee and went into the house for the first time after she'd purchased it. It was the day before Halloween. There was no electricity in the house, so she used the light from her cellphone to go all through the house, on every floor, in every room, up to the attic, down to the basement.

"You don't own me," she said in every room. "I own you." She wasn't certain to whom she was speaking, but she felt it was something that needed to be said.

A local contractor began work on the house and had been there for several days. Teddi stopped in to see how the work was going, and as they chatted, dusk began to fall. The contractor realized he'd left some of the work lights on on the third floor. With some embarrassment, he asked the diminutive Teddi if she minded accompanying him.

"The past is constantly alive in this house," he commented, "I can tell you that."

Teddi's children were immediately concerned. Her daughter, who was in the tenth grade at the time, complained that "someone touched me on the butt" as she lay on her stomach in bed to read. Soon Teddi began to notice that the candles she had placed on the mantle in her daughter's room were often found on the floor, as if someone wanted to make certain that they wouldn't be knocked over.

Around Christmastime, Teddi's daughter saw a man in the parlor and let out a scream. Teddi came running from the kitchen, but by then the man had vanished.

"There was a man in the parlor but he disappeared!" her daughter exclaimed.

"What was he wearing?" asked Teddi.

"Only *you*, Mother, would ask what a ghost was wearing."

But her daughter wasn't alone in sensing the stranger in the house. Over the years since then, friends have seen him as well as other spectral images in various rooms throughout the house. The most chilling apparition was witnessed by one friend who, as he left the house, looked back to see a little child gazing down at him from the second-floor window. He had just said goodbye to the entire family in the downstairs hallway, and the child was definitely not one of them.

It became commonplace for Teddi and her daughter to glimpse shadows that seemed to dart past the corner of their eyes, but when they turned, no one was there. When they were in the front of the house, muffled voices could be heard from the kitchen, but of course, the kitchen was empty.

Teddi's older son, a natural skeptic, chose the third floor for his bedroom. When he came home from college one weekend, he heard a noise and sat bolt upright in bed to see a dark figure in the doorway to the room. It remained motionless for a moment and then disappeared. After that, he refrained from scoffing at his mother's and sister's recounting of their experiences in the house.

"Now, do you smell anything?" people in town asked Teddi. "You could always smell Dr. Jeter's pipe in there," they explained nonchalantly, and Teddi knew they meant long after his death. "And the pies," they added, "can you smell the pies?"

Indeed, Teddi's family did smell pipe smoke in the parlor, and cakes and pies baking in the kitchen. But no one was smoking, no one was baking and no one else was in the kitchen or parlor.

Later, when Teddi's daughter was in college, one of her friends asked to get married in the garden as it was the perfect setting for a wedding. Friends of theirs, a young couple with a baby, stayed on the house's third floor. In the morning, the man apologized for having knocked over a decorative cup and saucer and offered to replace them. Teddi said it was an inexpensive piece and not to worry about it.

The young man later told her daughter's boyfriend what really had happened. He and his wife were sitting on the bed when the cup and saucer

on the nightstand beside them flew off their perch and went sailing across the room, crashing on the floor. Of course, no one had touched them.

The house is by the Chester River, and Adirondack chairs, decorative lights and a firepit grace the lawn by the water. On the property are two outbuildings, a carriage house and a shed once used as a smokehouse. Teddi has always felt that something was in them, a presence similar to what her family and guests sensed in the house. One day she noticed the names of the two little boys who lost their lives in the fire carved in the wall of the shed. It struck her that they would have of course loved to play in the little outbuildings and that they were still there and had never stopped playing. At least, she felt, the spirits of Millington Manor seemed happy.

And Teddi and her family live with them happily. Like Tracy and Jim at the Inn at Mitchell House, they had learned to accept the unexpected and unexplained. In the case of Millington Manor, many in town accepted, too, that the aroma of tobacco smoked by a man who had died a century earlier could still be smelled in the house's parlor, that the scent of invisible baked goods could be detected in its kitchen and that children no longer living gazed out its windows. As they had incorporated the memory of a respected doctor and the tragedy of the two little boys into their shared experience, so had they incorporated the fact that the spirits of these and other departed seemed to linger in the house. It is a true community, in the deepest sense of the word, that holds on to its past so fully.

It is no surprise that Millington remains a window to its past. Indeed, one of its businesses is a history shop, Old News, owned by Kevin Hemstock, local historian and former editor of the *Kent County News*. The history of Millington in this and other sections is credited to Kevin.

CHAPTER 9

TURN-OF-THE-CENTURY CHESTERTOWN

FOUNTAIN PARK

On any given Saturday morning, present-day Fountain Park in Chestertown is reminiscent of another era. Seemingly everyone comes to the Farmer's Market to purchase local produce, baked goods and crafts while chatting with friends and passersby. The park, with its lovely fountain, is as beautiful a centerpiece as any town could boast.

That was not always the case. In the late 1800s, citizens of Chestertown began to complain of the dreadful conditions of the town center, which had been a bustling market area in the previous century. Practically the only thing the town could boast of was an old cannon, origins unknown, which was dragged to various locations and used for public celebrations with much mishap. Fires were started, a building blown apart and, in one tragic incident, a baby in the arms of her nanny was struck and killed. The infamous relic can still be seen on Memorial Row and, needless to say, has remained unused for quite awhile.

Harrison Vickers, state's attorney, referred to the old market square as a "bare and windswept expanse of summer dust, or a dreary sea of winter mud."

Residents embarked on a mission to improve the attractiveness of the town's center and chose as a first project the development of a town park. Walter Pippin, local builder responsible for several of the elegant Victorian

The "town cannon" caused quite a bit of havoc during Chestertown celebration until it was retired from service.

Fountain Park was the first successful beautification effort in turn-of-the-century Chestertown. *Courtesy of Mark Newsome.*

houses on Washington Avenue, designed its layout. The centerpiece, however, was the fountain designed and manufactured by Robert Wood and Company of Philadelphia and purchased from the Town of Wilmington. Excitement grew over the unveiling of the town's new centerpiece, to be held on August 15, 1889.

The event was almost overshadowed by the scheduled arrival of the first automobile in Kent County, arranged by grocer John Vandergrift as part of the day's festivities. The beautification committee became the Chestertown Garden Club, which continues to help care for Fountain Park today.

But even lovely Fountain Park appears to have its ghosts, or at least reports of macabre shadows moving beneath the trees at night. Personally, it is difficult to think that anyone could find this lovely heart of downtown Chestertown, even in darkest night, unsettling.

STAM'S HALL

Another project focused on the need for a town hall. Other communities of the time had a central hall where programs could be held to entertain and educate the public, but not Chestertown.

A committee was formed in the 1880s, with local druggist Colin Stam among its members. When Stam inherited a piece of property where his drugstore was located, he proposed building an impressive hall on what would be known as Stam's Corner. The hall would be four stories, with commercial space on the first floor, small meeting rooms in the back, a large auditorium with high ceilings and a stage on the second floor and apartments above. Crowning the elaborate structure would be a clock tower, with the clock donated by the citizens of the town "to warn us by its solemn strokes of the flight of time and our approaching end."

The end result, completed in 1885, was truly an impressive structure and remains so to this day. The residents of Chestertown must have been exceedingly proud of their new hall. Certainly they used it well, and lectures, entertainments, graduations, dances and various performances were held in the second-floor grand hall. Some programs, at least, appear to have been open to all, including black residents, who, according to a local news article, composed a large portion of the audience for the performance of *Uncle Tom's Cabin*.

The *Kent County News* in 1903 described a Christmas dance at Stam's Hall attended by "all the recognizable names from Baltimore." Activities of that

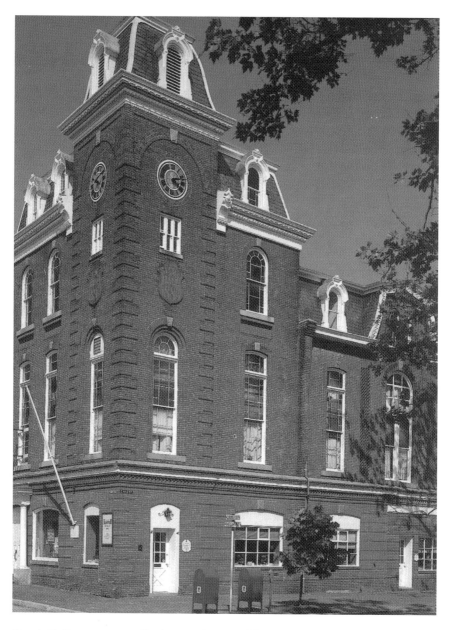

Stam's Hall's two-story auditorium on the second floor served as a center for Chestertown events.

sort no longer take place there, but its appearance still makes it a centerpiece of Chestertown.

And, of course, it seems to be haunted.

I had heard that there was a "presence" in the building from people who had been in the real estate offices located there. One former employee in the building said that her daughter was "good at sensing things" and had always said there was "something there," but another woman who had worked there was more specific.

She, too, was someone who could "see things." She had long felt that there was "something" at the end of the long hall that extends alongside the offices and can be entered from the door closest to the Prince Theater. There was a storage room at the end of the corridor, and when she was in there getting supplies, the door would open and close for no reason. She became accustomed to putting something at its bottom to keep it open when she was in the room.

One day, she saw a woman with a long skirt and high-necked blouse standing silently in front of the storage room. The figure stared back at her calmly and then disappeared. She never felt comfortable alone in the hallway again.

I asked her to specifically describe the figure. Was it solid, translucent? What actual shape did it take?

She thought a moment, then said, "It's difficult to explain, but it was as if I was seeing it in my mind, but it was still really there. I might even have projected the Victorian outfit on her, but she was really there."

Her words made me think of how the eye perceives color. A red apple is not really red, but it reflects the waves of light that makes the light receptors in our eyes see it as red. In other words, a red apple is only red in our minds. Perhaps there was something in that which could account for why some people see ghosts and others don't. (Maybe some of us have "ghost receptors" and some of us don't.)

During one of our first ghost walks, I was standing at the corner by Stam's Hall when a group of students who lived upstairs came out of the building. They used the side entrance on Court Street to reach their apartments. Inside the door is a wide staircase up to the second floor, with the auditorium straight ahead and the door leading to the apartments off to the side, as I recall.

"Are you doing ghost walks?" one of the girls asked me. "You need to use this building. There is *really* something up there."

When I asked for details, I heard the standard litany of unusual activity: footsteps, doors opening and closing, lights going on and off

and shadows out of the corners of their eyes. (One could almost write a job description for ghosts.)

"We're trying to find a medium or something, just to see what it is," she said. She gave me her number to contact her for more information, but by the time I tried, they had moved out.

I had been to the auditorium once to see if it could be used for one of our events. Even in the dim lighting, its woodwork and detail were still impressive and its vastness rather remarkable. The steps to the second floor would be a challenge for elderly or handicapped people in the crowd, which is unfortunate, as the space begs to be filled with activity again. One of the "sensitive" people I had met said that she felt when spaces built for human activity become unused for long periods, they develop and attract an activity of their own. One wonders.

THE IMPERIAL HOTEL

Another addition to downtown Chestertown that improved the community's offerings was the Imperial Hotel, established in the early 1900s by Wilbur Watson Hubbard, owner of Hubbard's Fertilizer Plant along the river. The story goes that Etta Hubbard thought her husband should have a suitable office space rather than one down by the fertilizer plant itself. The hotel offered, in addition to offices, a respectable establishment for traveling businessmen to stay and local businessmen to meet over lunch.

It has served the community since under various ownerships. The balconies on High Street offer a singular view of Chestertown street life. The interior is charming and welcoming and has been a continuing draw for residents as much as for travelers.

Its ghost is not particularly troublesome and appears to be simply a cold hand that touches the backs and necks of waitstaff and other employees when they're working in the basement level. One staff person and assistant manager said she was operating the meat cutter when the hand touched her neck. It was obviously not the ghost of a safety expert.

A story I heard from someone who worked there long ago was that the ghost of Etta Hubbard checks in sometimes to make certain that everything is up to her high standards.

THE VOSHELL HOUSE AND OUIJA

The Voshell House once sat on the corner of Spring Avenue and High Street. Built during the Civil War, it was in its time an impressive three-story hotel with commercial space below. Operating from there was a man named E.C. Reiche who had immigrated from Westphalia and ended up in Chestertown, where he became a successful cabinetmaker and undertaker. Some sources have credited him with the invention of the Ouija board in 1890.

The original source for this unusual claim to fame is an article that appeared in *New York World* magazine on May 23, 1920, with regard to the odd case of *Fuld v. Fuld* concerning who had the rights to the Ouija, the novelty board with which people could supposedly contact the departed.

According to the story supported by the article, Reiche had invented the talking board and passed the invention on to Charles Kennard of Chestertown, who then moved to Baltimore. Kennard, in turn, became involved with the Fuld Brothers and the establishment of the Kennard Novelty Company, which manufactured the novelty item under the enduring name Ouija (the Fulds later sold their rights to the Hasbro Company). There are elements of truth in all of that, but questions remain regarding Reiche's and Kennard's exact roles in the development of the Ouija. I leave that to be sorted out by the delightful Bob Murch, expert in all things Ouija. Murch, who has frequently visited Chestertown to research the origins of the "talking board," gave one of the most entertaining programs to a standing-room-only crowd at the Geddes-Piper House (after having presented the same presentation at the Baltimore Museum of Industry) and offers a vast store of information on his website at RobertMurch.com.

According to Murch, a talking board for those interested in communicating with the departed had apparently been invented in Ohio a few years earlier than Reiche's board was supposedly invented in Chestertown, although, as with so many inventions, it is difficult to attribute an exact source. The Ohio invention was called "The New Planchette," so perhaps even before that, there was the old planchette. Whatever the case, for a variety of reasons spiritualism was sweeping Victorian society, and these two Chestertown businessmen may well have jumped on the bandwagon.

What *is* known is that Kennard took advantage of a much more reliable form of communication and installed the first telephone line in Kent County at his local fertilizer business. He lived in one of the lovely Victorian houses on Washington Avenue, a photo of which appeared in early articles about the invention of the Ouija board.

Local legend has it that the Voshell House was haunted, but by a ghost that apparently had nothing to do with E.C. Reiche and his talking board. A local businessman who had his offices there apparently committed suicide in front of the building after the 1929 stock market crash. Old-timers used to say that a distressed man could be seen walking around the area at night, muttering to himself, and if anyone spoke to him, he disappeared. Faint gunshots were heard in conjunction with the sightings. After the Voshell House was torn down in the 1960s, the ghost no longer appeared.

CHURCH ALLEY AND THE TALL MAN

In spite of its charm, there were other dark deeds on the streets of Chestertown.

During the late nineteenth and early twentieth centuries, the *Kent County News* contained reports of lynch parties raised against black men for perceived crimes, quelled by local authorities, with one well-documented exception.

In 1892, a Kennedyville man named James Taylor was arrested for having allegedly molested a young white girl. He was secreted from the courthouse down Church Alley and put on a steamship to Baltimore for the first night of his arrest but then brought back and returned to jail in Chestertown. A masked mob succeeded (rather easily) in breaking him out of prison, dragged him over to Cross Street and hanged him near where the town hall now stands, his body left dangling afterward.

The crude drawing later produced of the incident, of a tall, slender black man hanging from the noose, is easily related to the story of the Tall Man, which appears among Alan Gorsuch's collected folk tales of Kent County. According to a man Mr. Gorsuch interviewed, the Tall Man could be seen in Chestertown along Church Alley. The teller said he didn't believe it, as he didn't believe in ghosts, but many people had seen it in Quaker Neck, Meliota and Georgetown (probably Georgetown near Fairlee), especially older people.

The specter was described as a tall, slender man in a black suit, long arms dangling and shoes cracking like new shoes. Once he's seen, he disappears. What relationship it had to anything, the teller didn't know.

The concept of a Tall Man is associated with urban legends, but other stories in Mr. Gorsuch's collection, shared by both black and white people in

Kent County, echo the tale of a tall thin man all in black, a specter who has been seen walking along darkened streets and country roads at night.

There is something that strikes me about this tale as particularly eerie. Church Alley, although only a block from High Street, can seem to be its own little world. Yet I have walked it many times in the dark, to my car at the courthouse lot, and never felt uneasy. But still, you never know…

CHESTERTOWN NURSERY TALES

Many of the stories I have heard sadly involve the apparition of a small child or perhaps the sound of a child or children playing.

Before vaccinations and antibiotics, diseases now easily avoided robbed nurseries in households at every economic level, and childhood and infant mortality rates were high into the twentieth century. The smallpox epidemic of 1898–1903 swept through Kent County, through the towns and countryside, before the vaccination for the dread disease was made universal. Just when the newspaper would report that it seemed to have dissipated, it would creep back into the towns and neighborhoods like rabid vermin.

It would be a rare house in earlier times that did not see death within its walls and, if a family lived inside, the loss of at least one child. At one time, it was not unusual for a family cemetery plot to have a row of little headstones.

There is a little girl who haunts a house on Queen Street. Her name is known, as well as where she is buried. But for some time after one of the historical society members moved into her house, the child seemed to think she was still at home.

The new owner noticed something unusual even as she was unpacking. From the third floor came the sound of a child singing, old songs as would have been heard long ago. When the homeowner went upstairs, of course it would stop. Then, on occasion, she would hear a sound as if someone was skipping. She wondered if she was losing her mind but was no less reassured when her neighbor told her about the little girl.

Still, she liked the house and the neighborhood and decided she could live with the sounds. However, she could not help but be relieved when the little girl seemed to go away.

Another woman told me of a house that she lived in on the edge of town. When her daughter and family came to stay with her for a time, her little grandson started to talk about his friend. They thought little of it, as

it's not unusual for children to have invisible friends, until they gave the boy a birthday party. As the children gathered around for cake cutting, the grandmother took a photograph, in which appeared the spectral image of a little boy, standing behind the others, smiling.

I was told of a family whose little girl had an invisible friend. The friend actually was useful, as, according to the little girl, she was teaching her how to clean. "Dusting, dusting!" the child would sing. Still, it began to disturb the parents, and they asked the little girl to leave her "friend" behind when they went out one day. As they got into their car, the little girl looked up and waved goodbye. Even the parents could see another little girl in old-fashioned servants' clothes waving back from an upstairs window.

WASHINGTON COLLEGE

The college has played an extraordinary role in the life of Kent County from its founding in 1783 to the present day. George Washington sat on its Board of Governors and Visitors, but even more importantly, many of the men whose names appear in these stories, who played an influential role in the life of their community and in many cases, of their country, were graduates of Washington College.

Notable women were also among its graduates. Washington College began admitting women into its "Normal" program in 1891 to be trained as teachers. As with their male counterparts, many contributed immensely both to their communities and to the broader world as well.

It is interesting to note that Elizabeth Emerson Callister "Betsy" Peale, Charles Willson Peale's sister-in-law, a well-known miniature painter, was employed to teach drawing and painting at the Kent County Free School and later at Washington College. She was quite possibly the first female member of a college faculty in American history. Betsy Peale designed the Great Seal of Washington College, still used today.

Of course, the college has its ghosts. Although there is little detail, I would be remiss not to include them. The haunted buildings on campus, according to student accounts, appear to be Tawes Theater, the Eugene O'Neill Literary House, Reid Hall and the Minta Martin dormitory. Tragic suicides, lovers' quarrels with fatal endings and hideous accidents are counted as the reasons behind the strange sounds, fleeting shadows and ghostly apparitions that have been described in the tales. The one specific encounter mentioned

One of the dormitories at Washington College.

in the *Elm*, the college's student publication, is an invisible cat that nestles in with the residents at Minta Martin, kneading their blankets with its paws and purring happily as it settles into bed beside them.

Perhaps it is a stretch to relate the following story to the college, but it does involve one of its professors.

The story of Thelma Buxton has no ghost in it. Still, it is a tale that proves, as always, the world of the here and now is far stranger than that of the beyond.

Kenneth and Thelma Boxton were a normal young couple living in an apartment along Water Street. Kenneth was a chemistry professor at Washington Collage, Thelma a homemaker. The two seemed to mesh well with the local social life and appeared to be settling into a completely unremarkable life.

Then, in 1935, Kenneth's widowed mother, Effie, moved into their one-bedroom apartment. Thelma began to show signs of mental fatigue; she attempted suicide twice and gradually appeared more and more distressed. Living in excruciatingly close quarters with her mother-in-law had taken its toll on the young wife.

Friday, September 27, 1935, started like any other for the Buxtons. Kenneth went to the college to teach, while Thelma and Effie remained at home. Their downstairs neighbors reported hearing groans around 8:30 a.m. but assumed the sounds were caused by another neighbor's dog that had been injured.

Around 9:00 a.m., Thelma came downstairs and told the landlady, "Call the sheriff. I've killed Mrs. Buxton. A doctor isn't needed."

The sheriff arrived shortly to find that, indeed, there was no doctor needed, as the elder Mrs. Buxton was very much dead. Thelma claimed she didn't recall picking up the hatchet and striking her mother-in-law repeatedly until the older Mrs. Buxton stopped groaning and moving.

What she did remember was kneeling over the body, covered in blood. She was taken to jail and then to a mental institution in Baltimore at the advice of the couple's attorney.

When the case came to trial, she was found not guilty by reason of insanity and committed to a mental hospital for a period of time. When released, she and her husband moved to Canada as, not unexpectedly, Thelma had come to be known as the Lizzie Borden of Chestertown.

But apparently, Mr. Buxton was willing to forgive and forget and didn't appear to mind the absence of his irritating mother.

To my knowledge, there is no ghost of either Mrs. Buxton at the residence.

CHAPTER 10
WOODLAND HALL

Although Kent County farmers worked hard to keep their land, and the old families, their homes, many were forced to sell at various times throughout the centuries of Kent County life, particularly during the Depression. Then, as now, Kent County's historic properties were advertised for sale, appealing to many from Washington, D.C., and the surrounding area who wished to experience their own plantation life.

"Most of the properties...have been sold to well-to-do men in the past ten years who can farm for a hobby, who can pay any price for what they want. The places have passed into new hands from families that have owned them for hundreds of years," wrote Evelyn Harris in *The Barter Lady*.

The story of Woodland Hall tells the tale of a family's determination to hold on to its legacy, a determination so strong that generations who had passed on seemed to reach out from the grave to help the next.

The grand old house sits a few miles from Shallcross Wharf, from which produce was shipped directly to Baltimore in the nineteenth and well into the twentieth centuries. As with other Kent County farm estates, it had made the transitions in agriculture necessary to endure. But perhaps because women played a strong role in its history, the focus of Woodland Hall's story centers more readily on family than on commerce and politics.

Woodland Hall was built in 1782 by Edward Wright, whose second wife was Elizabeth Ward Woodland. Interestingly, his great-great-granddaughter Julia Parmalee Morgan would design Hearst Castle for William Randolph Hearst. Another descendant would be related by marriage to Henry

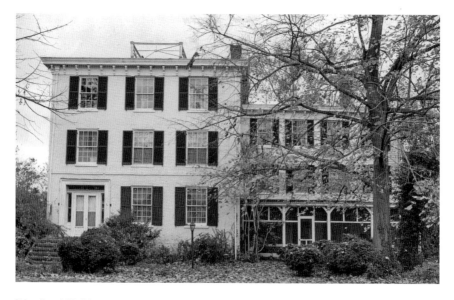

Woodland Hall has remained in the same family since its eighteenth-century beginnings.

Deringer, inventor of the Derringer pistol, and Edward Wright's son by his first wife would be the first person to die from the Bowie knife, wielded by James Bowie himself.

But it is not only those curious anecdotes that makes the story of Woodland Hall and its inhabitants unique. Rather, it is the efforts of the Woodland family over centuries to hold on to the legacy of land and family with determination and love. It should be noted that the history of Woodland Hall and its family is intertwined with two other historic properties nearby: Marsh Point and Scotch Folly. Woodland Hall and Marsh Point have been in the family since their establishment. Scotch Folly was sold out of the family in 1742 but bought back in 1939.

The family commitment to this centuries-old legacy is revealed in *Woodland Hall: Remembrances of the Family and Home*, by Mary Woodland Gould Tan and Virginia Carroll.

In my search for ghosts, I approached Mary Woody, as she is known, and her sister Margaret Anne "Maggie" Gould Cummings. Their family has been involved with the Historical Society of Kent County since its inception. Grandfather Simon Wickes Westcott Sr. was the society's founder, their grandmother Elizabeth Scott "Bess" Hurtt Westcott and Aunt Elizabeth "Beppy" Westcott Bryan both served as presidents of the society and their

cousin Robert L. Bryan Jr., who lives at Marsh Point, is the society's current president. The commitment of all of them to the preservation of the history and heritage of Kent County is obvious.

My first visit to Woodland Hall was prior to a cocktail party the society had there, and as I toured the house with Mary Woody, I had the same rare feeling I'd had when looking up at the antler stairs at the Hynson-Ringgold House. Initially, my sense was that, if there are places that are haunted, then Woodland Hall might be one such place. However, after listening to the story of Woodland Hall and the other tales presented in this book, I would say that "presence" is a more appropriate word. Whatever might be in the house, besides family and furniture, it is nothing unpleasant; it is just *there*.

Although, when I asked the bartender at the party, who is another cousin of the family, if the house was haunted, her reply was, "Hell yes!"

But after speaking with Mary Woody and Maggie, and reading *Woodland Hall*, it is very obvious that the word "presence" is by far the better choice. The house seems filled with a lingering determination that the legacy of family and land will not be let go, not even after centuries.

As Mary Woody said in her book's introduction, "People and homes interact and blend to create a history. If one listens, a house will tell the story of itself and its people."

Mary Woody and Maggie's role in holding on to family heritage began with the death of their mother in 2001. As Mary Woodland Westcott Gould lay dying in the home, she asked her children to "straighten out Woodland Hall."

At first they had no idea how to honor their mother's wishes, but then Mary Woody simply sat in the house and asked a question to know one in particular: *What should we do?*

The first clue they were given was a photograph a friend found by chance on the Internet. It was that of an old house captioned "Woodland Hall; Kent County, Maryland." It came from the archival collection of architect Julia Parmalee Morgan, the designer of Hearst Castle.

"Is this a picture of your family home?" asked the friend. The random finding of the photograph spurred Mary Woody and Maggie to look further, but where?

It would be difficult to know where to begin to find something specific at Woodland Hall. The furnishings and objects in the house compose what would be considered a museum of family history, with an overly full collection. As Mary Woody's daughter Ana Rebecca Tan Klenz writes in the book:

My grandmother, Mary Woodland Westcott Gould, lived in this wonderfully large historic house called Woodland Hall. How many people live in a house with a name, and their name at that? The house was so elegant with its many rooms filled with history. The whole third floor was a testament to previous times as there was no electricity up there. My grandmother forbade us to go to the third floor, but at night we would creep up the magnificent staircase for the thrill of imagining living in an era with no artificial light. Woodland Hall was filled with antiques and treasures from previous generations. Everywhere you looked there were objects that echoed from times past. Even the telephone was a generation old with its shrill brnng, brnng.

My grandmother never wanted to throw anything away and, living in Woodland Hall she didn't have to. Most people have to clean out their lives from time to time. My grandmother would just move her accumulated clutter from room to room. The passage of time would transform that clutter into something magical.

From the experience of both Maggie and Mary Woody, it could be imagined that someone was still moving things around from room to room, even though their mother had passed away. Both of the sisters would look for things, then return to the same place they had just looked and find the thing that they needed.

Mary Woody was sure that there were some family papers that would be helpful. After looking through everything, the drawers, the shelves and old trunks, she was sitting in the hallway, exasperated, wondering where to look next, when she realized her hand was resting on an envelope. There, of course, was the set of papers for which she had been searching. It was family genealogy written in 1978 by her mother's cousin. Then, later, digging through an old trunk for at least the second time, she found a detailed diary and family history their maternal grandmother, Elizabeth Scott "Bess" Hurtt Westcott, had written but never shared.

Some of the diary entries led the sisters to understand just how determined individuals from the previous generations, whom they themselves had known and loved, had been to hold on to land and family.

A central figure was their great-grandmother Mary Elizabeth Woodland Hurtt. Her father had bought Woodland Hall from his uncle, who was urged by his second wife to sell the property and move to Virginia. Many years later, Sara Emma Woodland Parmalee, whose stepmother had forced the sale, would write to Mary Elizabeth Woodland Hurtt. She had never

forgiven her "evil stepmother" for taking her away from Woodland Hall and was glad the witch hadn't been buried in the family cemetery, for that would have been hallowed ground. It was her granddaughter who became a well-known architect and in whose archives was found the photograph of Woodland Hall, which her grandmother had mentioned in her letters and treasured in her later years.

Mary Elizabeth Woodland Hurtt herself endured an evil stepmother and almost lost her inheritance upon her father's death. He had changed his will to disinherit her in favor of her stepbrothers, although it was after he'd been kicked in the head by a horse while riding. She took the matter to court, which ruled in her favor, saying that her father had not had his full faculties, and the estate was to be distributed evenly. In the process of distrubution, Woodland Hall was to be sold, but Mary Elizabeth gave her husband money to purchase it with her inheritance from her mother. Later, she asked him for her money back, as Woodland Hall was in his name. He had no funds to pay her, so she sued him. Again, the courts decided in her favor, and she was awarded direct ownership of Woodland Hall.

She might have learned this trick from her husband's aunt and uncle. The uncle, when threatened with a lawsuit, had deeded his property to his wife so that it would be safe. When the suit was settled, he moved to put the property back in his name, but she refused. He went to a Baltimore attorney who said he could advise him about what he could do for a fee of $100. When the uncle gave the attorney the money, the advice he received was: "Not a damn thing."

Mary Elizabeth, in turn, deeded Woodland Hall to her youngest son, Edmon Hurtt, who became "Uncle Eddie." He developed a very special relationship with his niece Bess's daughter and Mary Woody and Maggie's mother, Mary Woodland Wescott. As Elizabeth Scott "Bess" Hurtt Westcott recorded in her diaries, from the time her little girl was a baby, Mary Woodland had adored her great-uncle. The child's first words were "Uncle Eddie"; eventually she would simply call him "Sweetie."

Twenty years after his brother Julian's death, Uncle Eddie was urged by his mother to marry his sister-in-law, the beloved Mama Soph, as Mary Woodland called her. His mother then convinced the widow in turn to accept the offer, as she was afraid they would both be alone.

After Mama Soph died, little Mary Woodland would call for her to come. She was told that Mama Soph couldn't hear her, to which she replied, "Words travel on a current of air [something her uncle had told her], and she will come down." It was gently explained to her that this

wasn't true of the departed. Still, the little girl would continue to yearn for contact with those she had loved who were gone. When her great-grandmother, the indomitable Mary E.W. Hurt, died and was laid out in the parlor, little Mary Woodland cried, "I wish I could talk to GrannyMa, for just a little while."

Mary Woodland's father, Simon Wickes Westcott Sr., died at fifty-three. In his last moments, he attempted to say goodbye to his wife, Bess, and managed to scrawl in his weakened hand, "You are my all." She carried the slip of paper with her until her own death fifty years later at the age of one hundred and asked that it be placed in her coffin.

Those four words were much different from the poem he had written to her when he had gone away in the early stages of their romance:

I'm coming back!
There is no use,
Of making any old excuse,
I want to see you, yes and then,
See you again and again!
There's something in this world I lack,
So, as I say, I'm coming back!

But it was Uncle Eddie who came back first. He had lived on after Mama Soph's death and helped his niece with her children but then passed away when they were grown. Years after his death, his beloved grand-niece Mary Woodland had children of her own. One day the three of them, Mary Woody, Maggie and brother Eddie, still very small, were playing on the farm when a wagon filled with debris came loose from its hitch and started rolling down the hill toward them. The children froze, unable to run, and their mother, too far away to help, watched in horror. Without thinking, she screamed, "Do something, Uncle Eddie!"

With that, the wagon stopped, although it was still on an incline, only feet away from her children.

A few years later, Mary Woody was staying with relatives in Chestertown when she sat up in bed, knowing that something was terribly wrong. She was right: the rest of her family was traveling home in a blinding blizzard, and their car had gone off the road and down a steep bank. It was too cold to take the children, so only one of the parents could go for help, and Mary Woodland went. The bank was so steep and covered with snow and ice that she didn't think she could make it even that far.

Suddenly, she saw someone above her and then heard a voice say, "Take my hand. I'll lift you up." It was Uncle Eddie. He had come to get her out of the ditch. She would swear to that all of her life.

When Mary Woody, Maggie and brother Eddie's father died, he, too, was laid out in the parlor. Mary Woody went in by herself to say goodbye, only to find her tiny nephew trying to crawl in the coffin. "I want to take a nap with him," he protested as he was gently removed.

But the little boy wouldn't have long to wait to visit with his grandfather. A short time later, he remarked that he had seen Grandpa. "Where?" his mother asked.

"He floats above my bed at night."

When their mother was dying, her bed was put in the library. Moments before her death, she cried out: "They're here, they're all here, and they're lifting me up!" At long last, her children felt, she could speak with the people whose voices she had yearned to hear for decades. But her last words were for the living: "Sort out Woodland Hall." It was a final request to her family that they continue holding on to their legacy.

Maggie and her husband live at Woodland Hall now; brother Eddie passed away. Maggie has become accustomed to a presence; in fact, she feels comfortable with it. She is much more sensitive to that type of thing than Mary Woody and more open to the possibility that people who were once part of her life and the life of the house have not completely left. She sees shadows in some of the rooms, and once she saw her mother on the stairs. After her father died, he came to visit and spoke quietly to her while her husband slept.

One time she heard footsteps on the stairs, little ones and heavier ones. "Come on along," a voice said quietly.

Maggie does not say directly that there are ghosts in the house, only that she is open to the possibility that something is there, and it doesn't bother her. She loved all of her family when they were alive, and if they're there with her still, its only comforting.

"It's like looking at an abstract painting," she said. "Everyone sees something different."

The two sisters have grandchildren, and sometimes the little ones are bothered. One day, Mary Woody's tiny granddaughter, carried in her father's arms, cried out in the empty front hallway: "They're mad! They're mad at us!"

"Don't worry," said her older cousin, the little boy who had tried to take a nap with his grandfather, "they're fine." There was no one in the hallway but the three of them.

"Scary scary!" she protested again but was gently urged on by her cousin. "They're all fine," he repeated, motioning again to the empty hall, "and you'll be fine."

Things still get moved around; sometimes things disappear. But neither sister worries about it, as they'll always turn up again when needed, and when they ask a question of the house or their ancestors, they continue to feel that it is somehow answered.

Cousins they hadn't seen for years came to visit for a family reunion, and they, too, felt something. None of them was bothered.

Mary Woody is less sensitive to that type of thing, but as we discussed her search for family history and clues to the past buried in the house, she admitted readily that it was as if something was urging her forward and helping her along the way. And that was a good feeling for her. Since the two sisters began their project, the house has been placed on the National Register of Historic Places, and the property was designated a Century Farm.

"The house seems to shine when it's filled with people," said Mary Woody. "If there are spirits there, they want us to keep going as a family, in Woodland Hall."

CHAPTER 11

INTO THE TWENTIETH CENTURY AND THE GREAT EXPLOSION

Things had quieted down considerably in Chestertown by the mid-twentieth century. There were, however, two notable exceptions to the otherwise mundane life in a small town

The one happening spot in town in the 1950s that drew people from Baltimore was Charlie Grave's Uptown Club at Calvert Street and College Avenue. Performances by B.B. King, Fats Domino, Little Richard, Ray Charles, Otis Redding and other famous rhythm and blues acts put Chestertown back on the map again, and the old neighborhood of Santiago rocked.

In 2014, the historical society, along with other community organizations and individuals, honored the Uptown Club with Chestertown's first Legacy Day. More than 1,500 people filled the streets for the celebration. For the purposes of this book, I found myself disappointed that no one ever reported hearing mysterious music floating from the spot where the Uptown Club once stood, but obviously no ghosts are needed to keep the memory of those glory days alive.

And then there was the event that *literally* made Chestertown rock. The Kent Manufacturing Company near Radcliffe Creek produced M-80s, detonators and other explosives, including fireworks for use in military training, all under government contract. Highly explosive chemicals, devices and components were stored and handled continuously. The work was incredibly dangerous, and there was always the whispered fear among plant workers and townspeople that one day the place was going to blow. Yet it

was a good source of employment, particularly for women who made up the bulk of workers on the assembly line putting the explosives together.

The plant did blow, on July 16, 1954.

It was after all the workers were at their jobs in the plant when a massive blast shattered windows all over town. It was later reported that animals, including one man's pet monkey, died immediately, either from fright or having their eardrums shattered.

People in Chestertown knew what the sound meant right away. The plant had blown. Government inspectors would later say they had no idea what caused the first explosion, but it was clear what caused the second one. There was a store of M-80s in the building. Tragically, several people who escaped the first blast and returned to collect belongings or help their fellow workers were back inside when the M-80s exploded, sending up a plume of smoke above the town that was seen across the bay.

Many were wounded that day, and eleven were killed. Men rushed to the plant after the first blast and held up the chain-link fence for people to escape. One woman had left the plant but returned to get her purse and was killed in the second blast. She could be identified only by her jewelry. Another went back in to help a friend, and her body was never found. Her granddaughter recalled watching her mother search through the marshes at Radcliffe Creek to try and find some part of her. A temporary morgue was set up at the armory, and state police were charged with piecing body parts together.

One plant worker was seen by friends running terrified across the Chester Bridge. They stopped the car and asked if she wanted a ride. "I'm in a hurry," she cried and ran on. Another woman had stayed home that day to see her son off to the military. The two women who worked on either side of her were both killed in the explosion.

The National Guard was called in to secure the area. It was an eerie scene, one said. The building moaned and groaned, as if another calamity was forthcoming.

A few years ago, the historical society held a discussion group and oral history collection organized by Stephen Frohock, who later edited the society's book *The Great Explosion*. The program was the first opportunity members of the community had to come together and talk about the event, and more than one hundred people attended. Over fifty years later, the emotional impact that day held for so many was clearly evident. The poignant stories of people searching for the literal bits and pieces of their loved ones and of those who eternally pondered the fateful circumstances

that had kept them out of the plant that day or placed a family member in the doomed assembly line illustrated that not all the ghosts and phantoms that haunt us come from the supernatural realm.

Enormous changes in Kent County life came as it entered the second half of the twentieth century. The civil rights movement at last brought an end to centuries of publicly sanctioned policies of discrimination. Although racial tensions and private discrimination did not end, it was at least a step on the path toward normalcy. Kent County schools would be the last in Maryland to be desegregated, in 1970.

The Bay Bridge was built—the first span in 1959, the second in the 1970s. The isolation of the Eastern Shore was in many ways over.

Another wave of newcomers arrived, many of whom put their resources and talents into preservation efforts. Along with natives the newcomers embraced Kent County history, which has enormously enhanced the charm and uniqueness of this little jewel along the bay. At times, however, the popular focus on architectural heritage, the influential landed white families and the colonial heyday could overshadow stories that connected a broader range of people, black and white, whose experience has always been essential to the fabric of Kent County life.

CHAPTER 12
OUT IN THE COUNTRY

There are a number of crossroad villages in the county. Some remain intact, where neighbors still know one another and there remains a strong sense of community. Some are now just place names. All of them were once little worlds unto themselves. Many had their own little stores, post offices and churches, and all had their own social lives. Some are primarily black communities; others, primarily white. All were filled with hard-working people, many who farmed, hunted and fished and understood the water and land as no newcomer ever would. Their men served in the wars. Some were part of the Maryland 400 or served as militiamen in the War of 1812, and some died at Gettysburg. Many fought in the foreign wars, and those who returned came back to a world that, in many ways, was little changed. Their homegrown heroes weren't Revolutionary naval commanders or Civil War politicians but rather people such as Kent County farm boy Bill "Swish" Nicholson, a baseball Hall-of-Famer considered by many to be the greatest power hitter of the War War II era.

Like any rural region, Kent County crossroads had their tales and legends that connected people not just to one another and their past but also to the very land around them.

Living in the country offers an array of pleasures for the senses, that's certain: the smell of spring in the damp earth, an unobstructed view of the dome of sky that rests on the far horizon, the sound of geese calling that they're coming home.

But country life also offers a connection to the world that exists only when darkness descends. Fields that glowed gold in the sun become blanketed

Melitota Store was one of many country stores that served crossroads communities. *Courtesy of Mark Newsome.*

by a mist that creeps toward the light of houses distant from one another. Woods transform into mysterious places where things that hide in daylight wait in the dark for unsuspecting travelers to enter their shadowed lair. A road or bridge that people cross daily without thinking becomes a path that intersects with a parallel world.

In Robert Allan Gorsuch's collection of folktales and ghost stories, local residents shared with him stories passed down through generations of certain things to be feared at night at the crossroads and in the countryside of Kent County.

Specters along roads and bridges are a common theme among them. One of the lengthiest tales is told by a man who encountered a tall, slender man dressed in black on a bridge near Rock Hall. The exact location of the bridge is unclear, but people went to and from a church on it.

Something about the Tall Man bothered the teller of the tale as soon as he saw him, and he was determined to be prepared if he had any trouble passing the stranger. He planned that he would knock the man's feet from under him, kick him in the stomach and run. He approached the bridge,

ready for an encounter, but the man didn't even look at him, just stared past. Just as the fellow was passing the Tall Man by and it seemed as if he would have no trouble, his own feet flew out from under him. When he got up, ready to swing, the man was gone.

His family made fun of him for the tale, but then it turned out a neighbor had also seen the Tall Man when he and his wife were walking home from church. He, too, was bothered by the stranger on the bridge and instinctively pulled his wife toward him as they crossed. The couple looked straight forward, determined to pass, but when they got abreast of the man, he was no longer there. Other folks who saw him said the same thing. The first man who told the tale said he avoided the bridge at night thereafter.

What did he look like? Mr. Gorsuch recorded his words exactly: "He was tall and slender. He had on a dark suit of clothes and he was standin' just as erect as he could be. Had a hat, but kind of a round hat on his head."

Another older man whose story Mr. Gorsuch recorded recalled traveling at night by buggy from Pomona on a back road to Melitota and seeing three women along the road. He pulled up his horse to pick them up, but when he looked down, they were gone. He found out later that others had seen one of them along the road, but no one had seen the three.

Not in Mr. Gorsuch's book but still a popular Kent County tale is of the Cry Baby Bridge outside Millington. The story goes that a woman planning to leave her abusive husband hid her child below the bridge to pick her up at night when she fled (not a good plan), but when she came back, the baby was gone, and the woman, out of grief, killed herself at the bridge. People say on some nights, you can see the woman looking for her child and hear the baby crying.

Kevin Hemstock told me a story shared with him very recently by a man from Millington, which was recounted as an experience, not an old tale. Not too long ago, the man saw a stranger by Long Meadow Branch of Route 313 and wondered what he was doing there. As he approached, the man just disappeared, and it gave him, he said, the "heebie-jeebies." The place was near where Heighe Hill was attacked in the 1890s and left along the road all night, dying shortly thereafter.

Like the legend that enticed generations of children to jump up and down in front of Broadnox to see if the earth would shake, many of the tales offered a sense of chilling adventure for children through generations.

The tale of a "floating bridge" at Andelot Farms, haunted by a woman who died there, clings to the childhood memories of people in that part of the county. Karen Brice Clark shared this story in her own words:

Mr. Mac (Jim McFadden) used to take us raccoon hunting down to Andelot. Group of kids from Fairlee, the Kirby boys, Kirk Davis, more but can't remember! We used to walk across a floating bridge (always did this at night!). He used to tell a story about how Miss Annie Betts ran her horse and buggy in the water and was never found. If you walk real slow across the bridge, sometimes you can feel her breathing down the back of your neck!! And yes!, we did feel her presence!! Never did catch a raccoon!! He would build us a little fire down by the water. Many wonderful memories with him. Believe he passed away in the past couple of weeks at his daughters in the Carolinas.

In memory of Jim McFadden, loved his stories about the floating bridge down at Andelot!

Mr. Gorsuch's book also contains several accounts of a headless horseman by St. Paul's and on Olivet Hill Road outside Galena. I've heard the story from other sources that put the horseman at Edesville as well. Similar tales appearing in the book are of a headless dog that chased people across the fields and over fences at night. Among Mr. Gorsuch's collected stories are also those of a "winged man" such as the Jersey Devil or Mothman spotted around Rock Hall.

Kent County News in 1903 had a rather bizarre series of articles about "The Animal Seen in Kent," describing footprints discovered at Tolchestor and throughout the county of a horse-like water creature that came out of the bay, frightening people in town and country before it returned to the water.

The esteemed Reverend Clarence Hawkins of Edesville recalls hearing these tales from his childhood. He feels that they helped serve the purpose of keeping young people, especially teenagers, safe in their homes and beds at night.

A woman from Golts said she and her brothers and sisters, as well as their friends, were told to stay out of the family cemetery because it was haunted. When she went to pass the tale on to her own child, her mother scolded her, saying, "Don't scare the child! We just made that up to keep you out of there!"

The most frequent theme in Mr. Gorsuch's book are balls of light that darted across the roads at night, in front of horses and, later, cars. Some are described as balls of fire, some as will-o-wisps or jack-o-lanterns and some simply as glowing orbs. They were most frequently seen around Still Pond but elsewhere in the county as well.

Balls of light behaving mysteriously are not just from old country tales, however. In the 1970s, Linda Joiner Porter of Hainesville was driving along

Flatland Road when a glowing ball of light shot across the road in front of her. She was startled at first, but her shock turned to fear as the ball turned sharply to travel alongside her at the same speed as the car. Horrified, Linda kept driving with the ball of light beside her. It stayed in front of the woods but behind the houses along that stretch of road, always keeping pace with her car. The strange race with the glowing orb lasted three or four miles. Just as Linda passed the turnoff for Great Oak Manor, the ball shot across the road again and hovered no more than six feet in front of her car. For a horrible moment, Linda thought she was seeing the light that people saw before they die. And then then as suddenly as it had appeared, the ball went into the field on the other side of her and seemed to vanish.

Linda arrived home so shaken she could only sit on the couch and cry. Her father went out and saw the same glowing ball for a moment before it disappeared again. Her aunt, who had been driving down Flatland Road at about the same time, said she, too, had seen the ball of light but had decided not to tell anyone for fear they would think she was crazy.

To Linda's knowledge, no one saw anything like that before or since.

HAUNTED HOMES IN COUNTRY CROSSROADS

The following are stories shared with me by Jack Bigelow, who grew up near Pomona and now lives in Fairlee. Jack has no problem accepting the idea of ghosts, or whatever the strange occurrences that people experience in their homes might be, as he has seen and heard so many of them.

In fact, he grew up with a presence in his family home on Quaker Neck, an old farmhouse near the sharp curve past Pomona. The sound of footsteps would often be heard, and doors opened and closed for no reason. The grown-ups acted as if it was nothing and just referred to the presence as "Old Joe."

"They didn't hurt you when they were alive," his father said, "they won't hurt you when they're dead."

Friends of his who lived in Pomona had something more sinister in their home. Their children were terrified, as well they might be. They would look out the windows in their upstairs bedrooms at night and see a spectral face staring back in from outside. There were other experiences as well: footsteps across the attic floorboards, shadows moving past them that could only be seen out of the corners of their eyes and a chill in the hallways, as cold as a

refrigerator. You couldn't go in the house without getting goosebumps. The more the family talked about it, the worse it got.

They called in the priest, and he went through the house into each room, blessing it and then moving on to the next. Whatever had been there went away.

Another friend of Jack's lived in a house in which the previous owner had died. The man had smoked a pipe and had a beagle, and both he and the beagle could be seen from time to time, the man always jingling his keys and the smell of his pipe smoke lingering after he and his little dog were gone. As Jack's family had accepted "Old Joe," the people living in the house made room for the man and the little dog.

"We just like to think he's watching over us," they said.

It reminded Jack of a dear uncle who had passed away and whose own cigar smoke could be smelled from time to time, long after he was gone. At times, the family would catch a glimpse of him, standing in the back of the hall in the shadows.

At a Quaker Neck Landing house, the previous owner's son had been killed in a car accident. By chance, the people who bought and were renovating the house found an old flannel shirt shoved in a corner and threw it away. Later, they would from time to time see a man standing at the top of the stairs, wearing the same flannel shirt.

A dear friend of Jack's family who lived in Melitota worked for Delmarva Power and was electrocuted. Jack and his wife did anything they could to help his widow and family. One day, Jack's wife was mowing their lawn next to a ditch with a riding mower when it tipped over and trapped her beneath. A man driving by saw the mower flip, pulled over and rushed to help. In the few moments it took for him to get to her, the mower was upright and she was standing next to it. But no one had been there to lift it off her—no one visible, that is.

CHAPTER 13

HAUNTING IN GALENA

All the towns of Kent County have managed to survive the changing times better than many small towns elsewhere. Although life is different, they have adapted. As with Chestertown and Millington, the other towns remain close-knit communities, proud of their history, each offering a genuine and unique small-town charm.

Rock Hall may no longer be the capital of the seafood industry, but it is still a world of people who know the water. Its lovely harbors, bayside location and Main Street are a favorite destination for boaters on the Chesapeake.

Bettertown is no longer a bustling resort, but it hasn't lost its Victorian quaintness. Its beach is still a popular attraction, and its pleasant houses and cottages continue to offer a summer retreat for city dwellers.

Galena is still the crossroads it has been since colonial times, through which anyone heading north is almost certain to travel. An enterprising business community focuses on antiques, and Galena attracts many visitors looking for something out of the ordinary, which is well what they might find.

The town had its beginnings in 1763, when William Downs built an inn and tavern. The village that grew around it was referred to as Down's Crossroads and, later, Georgetown Crossing. George Washington traveled the road and stopped at least once at the inn on his eight trips through Kent County. As Rock Hall was the bayside gateway to Kent County, Galena and Georgetown were the closest stop in Kent County to the crossing of the Sassafras River.

By the time the town had been incorporated as Galena in 1853, it was a thriving community with a variety of stores, an oyster saloon and numerous other businesses. It had a cultural life as well and boasted Shrewsbury Academy, a private school that operated from 1817 until public schools were mandated after the Civil War. In the later nineteenth century, it had one of the finest libraries in the county and a three-story Oddfellows Lodge that was the centerpiece of town. Galena anticipated that the railroad would come through town, boosting local commerce even more, but that did not happen. Although the train went through Kennedyville, Stillpond and Worton, the nearest stop to Galena was one mile away at Lambson Station.

There has long been the story that Galena was named after a nearby mine, but no documented evidence of that exists, although some type of ore might have been extracted locally.

As with most of the other towns in Kent County, the bustle of commerce and culture faded. Yet Galena remains a pleasant and attractive community, noted for its antique shops and small eateries—and, as it turns out, more than a few ghosts. I share this story last because it is, in a sense, a tale of a more "modern" ghost and also one of the more unsettling tales that I have heard.

John Carroll, a local businessman who is active in the community, owns Village Antiques and Village Real Estate in the heart of Galena. His property is a conglomeration of buildings that have been moved together, creating a sprawling warren of sections and rooms. One part served as a post office but then was moved back from the main street, one section had been a funeral parlor, another was a church moved from Lambs Meadow and in the back and upstairs are apartments. The effect suits John's antiques business perfectly, as visitors are tempted to move from room to room, wondering what treasures await them. It's like the old curiosity shop on steroids.

But something awaits in parts of the building that might not be considered a treasure.

John is remarkably nonchalant as he describes the incredible range of bizarre phenomenon that are commonplace in the building. What he describes is beyond a mere presence; it is, without question, a genuine haunting.

But first, John shared with me a macabre array of strange happenings in the area.

There was an elderly couple who lived in town, and the wife was homebound with diabetes. The husband was nice but perhaps a little bit odd—he would wander around town, always talking. When he went missing

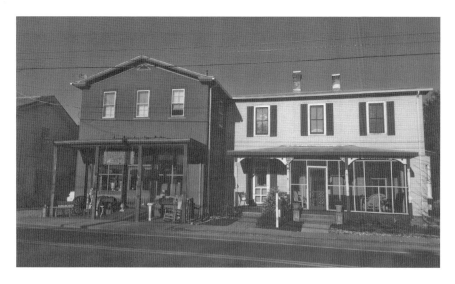

Village Antiques Shop in the heart of Galena. *Courtesy of John Carroll.*

from community life for a few days, it was at first as if everyone had a break, and then they started to worry. And then they detected the odor.

They entered the house to find that the man had fallen and broken his neck, and the poor wife was dead from a diabetic coma. In addition to the unfortunate souls the townspeople discovered, there was a supposed half a million dollars in cash stuffed in every corner. The man's brother inherited the cash and property, but the house itself could not be sold and had to be demolished, as no one would buy it, not even with the idea of finding more money.

Another lady living outside of town died in her sleep, and by the time her body was finally discovered, it had served as a buffet for her two enormous mastiffs, which were found playing with her head.

In one of the businesses, the owner sees the apparition of a little boy of about eight or nine who appears at the top of the stairs in the entranceway of his store. Toward evening, he can hear him moving about, and he has gotten into the habit of simply saying goodnight to the little boy.

A local contractor was working with his men in the attic of one of the buildings in Galena. They had difficulty dealing with something that kept turning the lights off, pulling the plugs out of their electric tools and touching them on the back. They were trying to get through before dark, but as dusk fell, they had to keep going downstairs to turn the lights back on. One of the men had to climb out on the roof, but when the trapdoor

slammed beside him at the same time the lights went out, trapping him on the roof and the rest of the crew in darkness, they decided to call it a night.

There were several suicides in town. In the location of one tragic death, the lights go on and off in the empty second-floor apartment, and footsteps are heard, but everyone rather graciously accepts it.

A suicide took place in John's building, too, back in the 1960s. The tenant hanged herself after finding out her husband had an affair, although rumor had it that there might have more to the story.

If that single death was the root of unexplained activity in the building, then there could well have been a *lot* more to the story, for whatever haunts the shop and adjoining office and apartments seems to insert itself into the lives of the building's tenants on an almost daily basis.

At night, footsteps are commonly heard crossing the second floor and going up and down the backstairs. Usually it is a long, lonely cadence that walks the distance of more than half a block and then retreats down the opposite staircase. Other times the footsteps shuffle across the second floor as if people were dancing to a fast-paced rhythm without music. The occurrences are so frequent that John and most of his friends and tenants have ceased looking for the source, as they know there is none—at least, none that is visible. His most long-term tenant, an elderly lady, continues to ask John who could be up there but always accepts that the answer will be "no one."

Whistling can sometimes be heard echoing throughout the building, a melancholy sound that always manages to keep ahead of anyone who dares to explore its source. The strangest sound is one that mimics human speech. It is usually heard at night while John and his friends are visiting. It is not uncommon for their casual conversation to be suddenly interrupted by a disembodied voice that parrots anyone speaking, even John's friend with a Queens accent.

But the most disturbing presence seems to emanate from a dead space in the middle of the building. After taking occupancy, John was bothered by a set of stairs that went nowhere. The staircase was in the building's center, where two other structures had been joined together. At the top of it was a solid wall. John assumed that if he opened up the wall, he would have another entrance to the other side of his property. When he knocked the wall down, however, he found behind it a locked door. He broke through the door with a sledgehammer to discover a small room; its only entrance was the door he had just dismantled, yet it had been locked with a dead bolt from

the inside. The room held an old mattress, and the mummified corpses of animals: a cat, squirrels and birds.

John's friends, even those who weren't bothered by the phantom voice that mimicked their conversations, found the room disturbing. Sounds started coming from the cell-like space after the wall was removed—rustling noises and whispers that could be heard during the day as well as at night. Someone told John that all the other ghostly activity in the property seemed to be centered in the dead space at the heart of the building. One friend stood in the room, trying to get a sense of what it was that bothered him about the space, when an ink-black shadow seemed to seep from the floorboards in the far corner and appeared before him, hovering for a moment as he stared at it, and then it melted back into the floor. Later, a similar black shape oozed out of the floor beneath John's desk as he and a colleague sat in his office. Like the shadow form in the little room, it hovered before them for an instant and then disappeared back into the floorboards.

John keeps the door to the room locked, and that appears to hold the dark shadows at bay. Meanwhile, the phantom footsteps, ghostly dancing, lonely whistling and parroting voice continue. The greatest skeptics among his friends have been turned into believers after an evening in the building, according to John. He used to live in one of the apartments upstairs but has since moved to an old church down the street that he's turned into a residence, and he enjoys the fact that it is as quiet as a tomb.

EPILOGUE
WHAT ARE GHOSTS?

.In the process of collecting material for the ghost walk and later, this book, I went from thinking that ghost stories are just good tales to be told in the dark to accepting the fact that ghosts—or however we wish to refer to disembodied footsteps, invisible hands and shadow figures—are somehow real. The people whom I interviewed are very credible witnesses, and the experiences they described were actual occurrences. Any attempt to attribute a natural cause to many of these incidents would require as great a stretch of the imagination as does the acceptance of the supernatural.

But if ghosts are real, what are they?

I came to wonder if what people were sensing wasn't some imprint from the past, the residue, so to speak, of someone who had been there before. When we sit in a chair or lie on a bed, after we get up, some essence of us remains, at least for a time. A bit of energy, usually body heat; perhaps a hair particle; and the space where we had been left a little disturbed, different, at least, than had we not been there. As some people have better sight or hearing than others, perhaps some people have better "ghost receptors," so to speak. They can see or hear these imprints from the past, while others see or hear nothing.

I mentioned this thought to Rodney Whittaker of the Maryland Society of Ghost Hunters, and he said yes, that is one theory, and its what is referred to as a "residual haunting." Some go so far as to believe that when people see what they consider to be ghosts, they are actually tuning in to events that happened or people who lived in another time.

However, I don't think that the ghostly experiences described to me were windows into the past, other than Kevin Maitland's strange auditory

experience at Tolchestor. In most other cases, the images that people saw and the sounds that were heard did not seem to be those of people going about their daily lives in another time period. Rather, they seemed to exist, at least in some part, in the present.

It is certain that what Rodney and the others encountered during their investigation at the Inn at the Mitchell House could not be described as a residual imprint. It was interactive. Rodney would ask the entity a question, and it would reply—perhaps primitively, but it was replying to him. That type of presence, he said, is referred to as an "intelligent haunting."

It remains difficult for me to conclude that ghosts are literally the spirits of dead people doomed to haunt the earth for eternity. Some incidents, such as Maggie Cummings's poignant encounter with her father, do seem to indicate direct contact between a living person and a dead one, usually happening shortly after the departed person's death. But most of the encounters described—the misty images, fleeting shadows and echoing footsteps—seem too primitive or vague to be accepted as an "intelligent haunting" by a departed soul. For example, various people at the Geddes-Piper House described seeing an image that could be taken for Polly Westcott, who had lived in the house for a long period. But never did I get the sense from anyone's description that "Aunt Polly" was roaming around the house wondering why we'd made such a mess in the bedroom we had to make do with as an office.

Whatever turned the flashlight on and off at the Mitchell House seemed to be feminine, perhaps a child, but it was not as if she indicated she went by a certain name and lived in a certain time period. Was the entity perhaps an "echo" of a little girl who had once lived in the house? Did the presence of a medium (presumably with good "ghost receptors") enable the echo to interact with the living?

I asked Rodney what he thought this type of phenomenon is, and he replied that all he could state with certainty is that it was some form of energy. We are all made up of energy, and ghosts are some form of it that we do not yet understand.

His use of the word "energy" struck me. From Rodney's accounts of his investigations and having myself heard of EMF readers and other gadgets ghost hunters use, it occurred to me that electricity and electromagnetism seem to be key factors associated with paranormal phenomenon.

Following my discussion with Rodney, I had an unusual exchange with a woman during a meeting of a nonprofit board on which I sit. She is a very distinguished and accomplished lady—nothing odd about her at all. A fellow

board member mentioned laughingly that it was difficult to use electronic devices around her, as she had a condition that sometimes interfered with their functioning. Sure enough, the other person's laptop wouldn't work in her presence. Other times, they said, she could have the same effect on cellphones.

Without thinking, I found myself asking the lady with the electronic gadget problem, "Do you see spirits?" immediately wondering if I had completely lost my senses.

She looked at me for a moment and then replied, "Yes, I don't normally talk about it because it makes me sound strange, but I have."

She shared a few experiences of seeing spectral images of family members who had died, and then the meeting dissolved as the others at the table began sharing their own strange experiences. It was highly enjoyable but left me with no more information than that a woman who has a condition I've never heard of involving an unusual interaction with electronic devices could see dead people. Still, it hinted at a curious connection.

I did some cursory online research on electromagnetism and ghosts. Skipping over the paranormal and ghost hunting sites, I found an article in the *BBC Science and Nature News* edition of May 21, 2003, discussing university research into the correlation between people claiming that a place was haunted and electromagnetic fields in those places.

Summing up the article's contents, it appears that researchers in psychology are aware that the places people consider to be haunted do genuinely have higher electromagnetic activity.

"The high-density haunt areas, usually not more than about one or two metres in diameter, are very electromagnetically noisy," according to Dr. Michael Persinger of the Laurentian University in Ontario, Canada.

However, because they're scientists and don't believe in ghosts, they conducted experiments to see if the same conditions created in controlled settings can produce in subjects an experience similar to a ghostly sighting. In other words, researchers wondered if greater electromagnetic activity makes our brains see ghosts rather than ghosts creating greater electromagnetic activity. This was based on the knowledge that applying electromagnetic stimulation to the brain can produce experiences such as fear, hallucinations, etc.

The experiments didn't work. Subjects sensed ghosts in places that were supposedly haunted, but scientists couldn't make the same subjects see ghosts by exposing the brain to the same level of electromagnetic activity present in the supposedly haunted place.

In the BBC News item, the vice-president for the Society of Psychical Research of London was interviewed, along with the research scientists. He

stressed that the *same* apparitions appear to different people in "haunted" places, while electromagnetic stimulation of the brain produces *different* results, including different hallucinations, in different people.

Out of curiosity, I did another online search of the phrase "scientists who believe in the paranormal."

That took a second to reveal a very tiny club but one with an extraordinarily elite membership: the renowned physicists Freeman Dyson and Brian Josephson, Nobel Prize winner. Although both are universally considered among the most respected physicists in the history of the science, they have received criticism from colleagues for their acceptance of the existence of paranormal phenomenon (although the reputations of both can take the heat, I am sure).

Dyson has stated, "Paranormal phenomenon are real but outside the limits of science," while Josephson has said, "I think that quantum physics will help us understand its properties."

Those two comments by these esteemed gentlemen let *me* off the hook for making any further attempt to guess at what it is that appears to exist alongside us yet remains totally inexplicable. Still, I confess to having some vague notion that paranormal phenomenon might have to do with the manifestation of electromagnetic energy, which might possibly be some type of residue of people no longer alive. Sliding down this slippery slope of commentary even further: it seems that some people have a unique ability to more readily detect and even interact with that energy or residue.

But when that residue starts throwing wrapped chocolates down the stairs at us, that vague notion doesn't seem to hold much water.

This I do believe: there is much to this world that we don't begin to understand but should not out of hand dismiss.

There was a time when I thought I might live out my life in Chestertown, but such was not to be the case. Although I had so enjoyed my years at the historical society, helping connect residents and visitors to Kent County's rich history, I decided to return to the place of my own roots in the mountains of southwestern Pennsylvania.

On my last day of work at the Geddes-Piper House, I found myself alone in the front hall at twilight, about to leave behind the little world of which I had become so fond.

My hand on the doorknob, I could not help but turn around and say to no one, "Don't worry, you'll all be fine."

BIBLIOGRAPHY

BOOKS

Berna, James L., and Michael Bourne. *The History of Airy Hill, Chestertown, Maryland (1688–1996).* Chestertown, MD: self-published, 1996.

Bourne, Michael. *Historic Houses of Kent County.* Chestertown, MD: Historical Society of Kent County, 1998.

Bruegger, Robert. J. *Maryland: A Middle Temperment, 1634–1980.* Baltimore, MD: Johns Hopkins University Press, 1988.

Duvall, Elizabeth S. *Three Centuries of American Life: The Hynson Ringgold House of Chestertown.* N.p.: self-published, 1988.

Frohock, Stephen, ed. *The Great Explosion.* Chestertown, MD: Historical Society of Kent County, 2010.

Gorsuch, Robert Allan. *Ghosts in Kent County Maryland.* N.p.: self-published, Robert Allan Gorsuch, 1973.

Hemstock, Kevin, ed. *Tales of Kent County.* Chestertown, MD: Kent County News, 2006.

Hickey, Donald. *The War of 1812: A Forgotten Conflict.* Champaign: University of Illinois Press, 2012.

Middleton, Arthur Pierce. *Tobacco Coast.* Baltimore, MD: Johns Hopkins University Press, 1985.

Sutton, Stanley. *Beyond the Roadgate: Kent County 1900–1980.* Chestertown, MD: self-published, 1980.

Tan, Mary Woodland. *Woodland Hall: A Remembrance.* N.p.: self-published, 2007.

ARTICLES, DISSERTATIONS AND THESES

Cawley, Alexa. "Household and Community, Kent County Maryland 1631–1676." UMI Dissertation Services, 2004.

Fyock, Melissa. "The Industry of Ghost Tours as a Unique Manifestation of America's Obsession with Ghosts and Ghost Stories." Washington College Senior Thesis. Chestertown, MD, 2010.

Goodheart, Adam. "Tea and Fantasy: Fact, Fiction, and Revolution in a Historic American Town." *American Scholar* 74, no. 4 (Autumn 2005): 21.

Manning, M. Chris. "The Material Culture of Ritual Concealments in the United States." *Historical Archaeology* 48, no. 3 (2014): 52–83.

Pleasants, J. Hall. "The Letters of Molly and Henrietta Tilghman." *Maryland Historical Magazine* 21, no. 1 (1926).

ONLINE RESOURCES

Ellefson, Ashley. "The Private Punishment of Servants and Slaves in Eighteenth-Century Maryland." Maryland Archives Online, 2010. http://aomol.msa.maryland.gov/megafile/msa/speccol/sc2900/sc2908/000001/000822/pdf/am822.pdf.

———. "Seven Hangmen of Maryland." Maryland Archives Online, 2009. http://aomol.msa.maryland.gov/megafile/msa/speccol/sc2900/sc2908/000001/000819/pdf/am819.pdf.

Righi, Brandon. "'A Power Onto Our Laws': A Study of the Effect of Federal Policies on Border Unionism in Kent County, MD 1861–65." Washington College, A Revolutionary Project. https://www.washcoll.edu/centers/starr/revcollege/300years/apowerunknown.html.

Steiner, Bernard Christian, ed. Archives of Maryland, vol. 41: "Proceedings of the Provincial Court of Maryland, 1658–1662." http://aomol.msa.maryland.gov/000001/000041/html/am41p--1.html.

About the Author

Diane Saylor Daniels served for seven years as executive director of the Kent County Historical Society. Originally from the mountains of rural Somerset County, Pennsylvania, along the border of Garrett County, Maryland, she understands what it is like to truly be "from" a place and enjoyed having an "in" to the centuries of stories woven into the fabric of life in Kent County. Prior to working at the society, she had been the director of the public library in her hometown, having returned to rural life following twenty years of working in nonprofit and university administration in Pittsburgh, Pennsylvania, and New York City. After the death of her husband, Bill Daniels, Diane decided to return to her native Laurel Highlands to be closer to friends and family, particularly her daughter and son-in-law, Anne and Joe McLaughlin, who live in Pittsburgh. She enjoys living in the mountains with her dog, cat and pet goat.

Visit us at
www.historypress.net

This title is also available as an e-book